A Modern
Photo
Guide

Basic Child Photography

Minolta Corporation
Ramsey, New Jersey

Doubleday & Company
Garden City, New York

Photo Credits: All the photographs in this book were taken by J. Alexander unless otherwise credited. Cover: J.O. Meadows; p. 3: J. Alexander; p. 4: J. Alexander

Minolta Corporation
Marketers to the Photographic Trade

Doubleday & Company, Inc.
Distributors to the Book Trade

Library of Congress Catalog Card Number 81-71224
ISBN: 0-385-18158-2

Cover and Book Design: Richard Liu
Typesetting: Com Com (Haddon Craftsmen, Inc.)
Printing and Binding: W. A. Krueger Company
Paper: Warren Webflo
Separations: Spectragraphic, Inc.

Manufactured in the United States of America
10 9 8 7 6 5 4 3 2 1

Editorial Board

Publisher	**Seymour D. Uslan**
Project Director	**Herb Taylor**
Editor-in-Chief	**William L. Broecker**
Technical Director	**Lou Jacobs, Jr.**
Project Coordinator	**Cora Sibal**
Managing Editor	**Linda Z. Weinraub**
Contributing Editors	**Jules Alexander**
	Algis Balsys
	Charles Marden Fitch
	Michele Frank
	Elinor Stecker
	William Tyler
Editorial Assistant	**Kevin Clark**

Contents

Technique Tips

Throughout the book this symbol indicates material that
supplements the text and which has been set off for your
special attention. You can apply the data and information in
these Technique Tips immediately to get better results in
your photography.

Introduction

When was the last time you saw pictures of yourself as a child? If you have an old family album nearby, take it out and look at the photographs of yourself and other children. If you are like most of us, some of the images will make you smile as you remember a particular event or feeling; others will make you slightly embarrassed because you think you look silly, or because you remember being made to pose uncomfortably for the camera.

The "Okay, kids—now look at the camera—hold still—smile!" kind of picture will usually be the worst of the batch. Those made of you and your friends as you played, got your first haircut, or toddled along the park lane oblivious to your parents' camera will remind you most of what your early days were like.

Things are much the same now as they were when you were small. Child photography is still the most popular form of people picture making, and posed photographs that have nothing to do with the child's life are still the least interesting. Unfortunately, they seem to be the ones people make the most often.

It does not have to be this way. All you need to make compelling photographs of children are familiarity with your equipment and a good understanding of what being a child is about. The equipment you choose is secondary—good pictures of children can be made with the simplest cameras and lenses. Your understanding of children, though, will have a marked effect on the outcome of your photographs. The closer you can get to seeing the world as children see it, the better your pictures of them will be.

Express the relationship between two children by having them interact during the photo session. With the simple gesture of touching, these youngsters show us that they belong together.

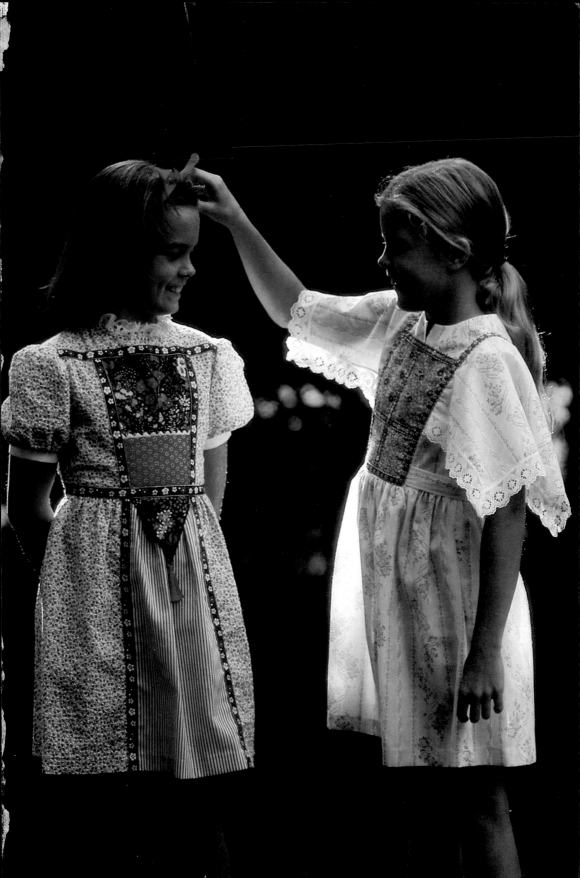

Often the most effective pictures of children result from entering the child's world. A subject does not have to look straight into the camera and smile in order for you to make a successful picture. Photo: D. Ramage.

Whether you are going to make pictures of your own kids or of other children, the first thing you must do is watch them. Get to know how they behave with one another, with their toys and pastimes, and with adults. Study their faces and bodies when they see someone they like or dislike; when they are taken to the zoo for the first time; when they find something in their environment interesting, funny, or scary.

To find out for the second time in your life what the world looks like from a child's viewpoint, get close to the ground. Make notes about the attention spans of children at various ages; watch other adults deal with them, and gauge how successful their different approaches are. All of these things will help you understand your young subjects better and make it easier to make photographs that both record their lives and show your audience what your feelings about children are. If you

are really successful, you might even give your older viewers a sense of childhood they had long since forgotten.

If you are comfortably familiar with your camera and film, you are halfway down the road to successful child photography. The two remaining requirements are attitude and timing. Timing will come with practice; the attitude you will have to supply right from the start.

The following chapters discuss various photographic, technical, and emotional tools that you can use to make meaningful photographs of children. There are sections on various cameras, lenses, and films. There are suggestions on how to best capture the special and every-day moments of children, on how to build a record of your kids' growth, and on how to begin a visual journal of children in your time.

Photographing children is one of the most rewarding and fun-filled pursuits the medium has to offer. It gives you a chance to narrow the gap between your understanding of the world and that of the young people sharing it with you. Through the pictures you make, you might get to know one another better. More often than not, you will find that the pictures you make of children being themselves will give you an invaluable bonus—a fresher, more childlike appreciation of everything around you. What better gift could there be for a photographer?

A magical moment like this is unlikely to occur very many times and there is no practical way of doing it over again. Take care of as many technical concerns as you can (exposure readings, film advance, etc.) before you begin to look for pictures. Photo: J. Peppler.

Cameras, Lenses, and Film

The best equipment for general child photography is whatever you use most often for the other kinds of pictures you make. The more comfortable you are with your hardware, the less you will be thinking about it—so you will have more time to concentrate on getting the best pictures you can. A simple 110 camera, a small 35mm compact, or your interchangeable lens 35mm SLR are all fine for photographing children. Even the old, boxy press camera you may have inherited from a photographic relative will make wonderful pictures of kids, if you use it properly.

Use your common sense to choose cameras for photographing children. You will not have much luck capturing the movements of agile, fast moving seven-year-olds with a large view camera, for example; nor will you be able to produce a large, high-quality portrait print if you take the picture with a pocket camera.

Pick a camera and lens based on the kind of picture you want to produce. In any event, try to stick with equipment that you will not need to fiddle with as you go about making your pictures. If you are interested in photographing children on the move outdoors, carry the least amount of camera gear you think you will need. In most instances, this will mean a small 35mm camera and one or two lenses, or a short zoom lens. For better picture quality, use slow, small-grain films. If you are making pictures indoors, use faster films, and adjust the light level of the room beforehand, if possible, so that you can shoot without using

An important consideration in choosing a lens for a particular photograph is how large you want the subjects to be in the frame. When you want to include a significant amount of surrounding area, a wide-angle lens is a good choice. This picture was made with a moderate wide-angle 28mm lens.

The same scene photographed with a 50mm lens—the "normal" lens for 35mm photography. Notice that the subject is larger in the frame than before, but that there is less environment.

flash. If using a flash is unavoidable, be prepared to waste a few frames, until your subjects get over the novelty of the electronic "lightning bolt" each time the flash goes off.

If you want to make more formal pictures and have a choice of cameras to work with, use the largest film-size camera you can; plan your shooting in advance, setting up the lights and arranging the

A moderate telephoto can be especially useful when you want to fill the frame with your subjects without disturbing them. For the same size image, the camera-to-subject distance is over twice as long for a 135mm lens—the one used here—than for a 50mm lens.

background before you begin. Here again, use as little equipment as you can get away with. Your camera, a tripod, and light coming in through a window may be all you need.

If you are making color pictures, make sure to match the color balance of your film with the light you are using it in. Daylight color films will work well only in daylight or with electronic flash. If you use them in indoor light without flash or special compensating filters, your pictures will have a reddish cast. If you do the reverse and use tungsten-balanced film outdoors, everything in your pictures will look bluish. Depending on which mistake you make, your children will appear to be freezing to death or suffering from jaundice.

Indoors or out, choose a lens or (if your lens is permanently mounted) a camera position that will not interfere with your subject's activity.

Small children are rarely predictable, are easily distracted, and are not particularly interested in holding still for the camera. They are also quick to respond to any lack of patience on your part. If you keep

Nothing is ever quite the same twice. Allow yourself the freedom to try new ideas. If they work, you're a genius; if they don't turn out well, it was only an experiment.

an easy to use, small camera handy and let the picture situations happen instead of trying to force them on the child, both of you will be happier—the child will get used to your being there with your camera, and you will find yourself able to record characteristic pictures of your subject more and more often.

Photographing children is not that much different from photographing life on the street—the picture can happen at any moment, and if you are not alert, might catch you unaware. Become part of the child's surroundings, and stay alert. With practice you will be able to anticipate the moment your shutter ought to be fired.

Caution and adventure can go hand in hand. Make sure you have a usable picture when experimenting by taking a few straight pictures.

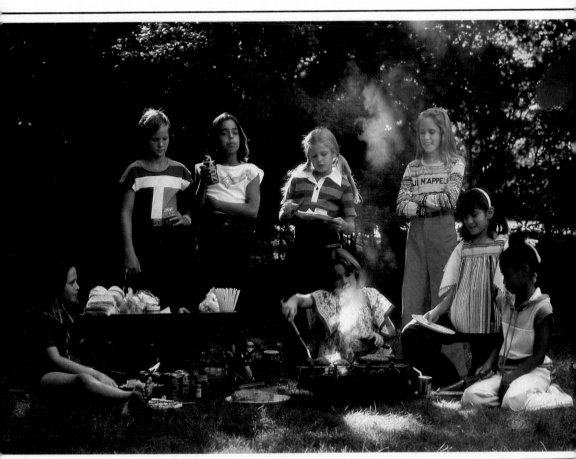

1

Baby Pictures

All babies are beautiful; or so the saying goes. However, many baby pictures make you wonder if beauty was in the eye of the paternal or maternal photographer. Many baby snapshots show newborns and toddlers as wrinkled, reddish, crying little creatures who look terribly uncomfortable; and that is to some extent exactly what they are. But they are also creatures full of questions they do not know how to ask, devouring with their eyes everything they see; grasping anything that comes near their searching, inquisitive fingers. They are little humans who cannot speak, but are masters of non-verbal communication. They are demanding and manipulative; delightful and loving; frustrated and wise all at once—and they are perfect photographic subjects, since they are less self-conscious now than they ever will be again.

Baby pictures do not have to be made on a bearskin rug; nor do they have to be closeups of drools or teary faces, with nothing in the picture to indicate what all the moisture is for. On the contrary, baby pictures can record the first episodes of someone's life; or they can commemorate a time when all of us experienced total freedom from self-consciousness—a time that none of us remembers.

If you are a new parent, or someone interested in making meaningful photographs of babies, the first thing you should do is forget most of the baby pictures you have seen. Look at babies instead. Examine the way they examine their new world. Try to find what it is that has just made them laugh, sigh, or start (it will not be easy some of the time). See how much you can learn about their cycles of tiredness and activity; about what delights or frightens them. Watch them explore their own bodies, and their own small environment. Watch babies of all ages.

Innocence is a delicate quality. As with fine crystal. the best way to avoid damaging it is to not tamper with it—use a simple direct approach. Photo: J. DiChello.

From The First Moment On

If you are a good friend of a new parent, you have the chance to begin what could turn out to be one of the most rewarding photographic projects you will ever undertake—the documenting of a baby's first days.

The first weeks of a baby's life are spent sleeping, feeding, and crying, mostly. This may seem a little boring, photographically speaking, but watch the infant's sleeping face go through a myriad of expressions. Photograph the more expressive ones, as well as those that are often repeated. Make notes so that later you will be able to tell which expressions were characteristic.

Photograph the baby as he or she feeds, whether it be from a bottle or the mother's breast, if the mother does not object. Pay attention to small but telling events: the mother's hand on the baby's head; the tentative way the father holds his child, and other such moments.

Watch the baby as he or she cries. Does one expression indicate the baby is tired and another indicate hunger? How long does it take the parent to comfort the baby?

Flash Alert. When photographing an infant, a flash that is too close or too intense can harm the child's eyes. Shoot from a safe distance when using flash, so as not to harm the infant, or disturb the environment. A quiet camera would be a definite asset—if you have a camera case, use it; it will diminish the noise somewhat. Make a lot of exposures, and edit them later. Try to establish a flow to the pictures you have made.

Eye-level portraits are just as important with children as with adults. Either get down to the baby's level or use a safe raised support. When feasible, the latter choice is a spinesaver. Photo: T. McGuire.

When a child has learned to crawl, You'll need space for a photographic setting. Light as much of the area as is practical; there's no way of knowing which direction the baby will decide looks promising. Photo: N. deGregory.

Technique Tip: Photographing The Newborn

Bring your 35mm SLR or other small camera and some fast film so that you can shoot in available light—the parents will be too concerned with their new family member to have much time to help you set up lights or fuss with a large tripod. Take a zoom lens, if you own one. This will let you take photographs of the mother and child together, closeups of each of their faces, and wide shots of the room without moving from your position. The less obtrusive you are, the more responsive they will be to future shooting sessions.

Let the baby realize you are there, and do not make any sudden moves in the baby's direction. This may sound like needless advice, but in your eagerness to capture a particular expression on the baby's face, you might lean in suddenly and frighten mother and child both.

Pay attention to the way mother and father interact with the child and with each other—the baby's life is totally linked with that of his or her parents at this stage, and your photographs should show that.

Toddlers

As babies grow to the point where they can crawl about and then get up on their own and toddle, a whole new world opens up to them—and to you as a photographer.

Toddlers have a developed sense of humor, a questioning nature, and a language they alone have full command of. They are inquisitive about everything around them, and are often fascinated by objects long enough for you to make a number of pictures at a time. Pay attention to the way a child who is just beyond the crawling stage stands up— each child has his or her own method of establishing balance and getting about. Children at this stage are not at all self-conscious, and have no knowledge of what a camera does. They have also learned to respond to their names. If you want a picture of the child looking into your camera, call his or her name; the child will look up and notice the strange contraption in front of your face. More often than not, the toddler's curiosity will keep him or her still long enough for you to make an exposure, even at slow shutter speeds.

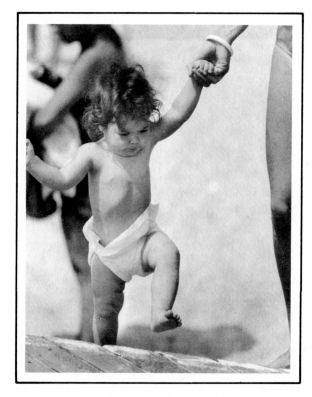

Many of the skills older people take for granted are an effort of will for a young child. The learning process is good picture material. Photo: J. Peppler.

18

Activities. Watch, then photograph, how the child plays with favorite toys, or with the family pet. Children this young can make life for a dog or cat rather trying; surprisingly, many pets sense that the child means no harm, and they put up with behavior that they would never tolerate from their older masters. Toddlers and pets can make a wonderful photographic combination; but if you are not careful, you might find yourself making poor greeting-card pictures rather than photographs. Be suspicious of anything that could be described by the words "cute" or "sweet."

Eating. Toddlers often have a unique way of eating or, rather, playing with their food. They make no bones about what foods they find palatable and which they would rather pass up. Sometimes, food becomes airborne. Protect the lens with a skylight or UV (ultraviolet)

As a child gets older the opportunity for interaction between you and the subject increases. Don't hesitate to use a friendly bribe to enhance the relationship. Nothing makes for a pleasant photo session like an ice cream cone.

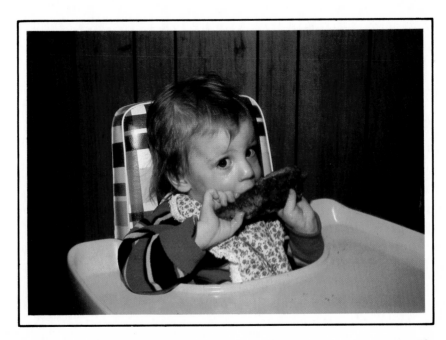

A good time to take pictures is just before bedtime, when children become especially active. Use roomlight when making these pictures; bursts of flash can easily turn an overactive toddler into a cranky one. Photo: N. de Gregory.

filter if you are photographing a toddler at the table. If the child is still being spoonfed, be alert for any devious ways he or she has developed for dealing with unwanted mouthfuls. One mother reports that her young son would wait until the spoon almost reached his mouth, then he would turn his head—the spoonful of food would then be fed to his ear. Such a picture might not be elegant, but it is an invaluable image to add to your family album.

Use a fast standard lens, or a zoom with flash for pictures of toddlers. They scoot about rather quickly, changing direction unpredictably, so your equipment should be geared to arresting movement. The electronic flash will not bother the youngster unless you fire it into his or her eyes directly. Use bounce flash when possible.

Bedtime and Bathtime. Photograph the toddler in his or her crib, using roomlight; firing off an electronic flash unit at a sleepy toddler might cause a certain amount of noisy displeasure. Watch for changes in expression as the child dreams, and look for characteristic body positions.

Toddlers either love or hate being bathed—they are rarely stoical about it. The reaction can be anything from violent protest to a grimace; from an openmouthed smile to a splashy delight. If the child is demonstrative, protect your equipment from splashes as you would in the rain.

Minor Tragedies. The small tragedies in a toddler's life should be recorded as well as the pleasant moments. Anger, pain, and unhappiness are all valid and important events in a toddler's life, and he or she will be too preoccupied at such a time to care about you or your camera, so you will have plenty of time to make exposure readings and to frame your picture.

It is not always necessary to show a child in a happy mood. Sadness, anger, or, as shown here, fatigue after a pre-Halloween visit to a pumpkin farm are all part of a child's life and legitimate subjects for photography. Photo: G. Kotler.

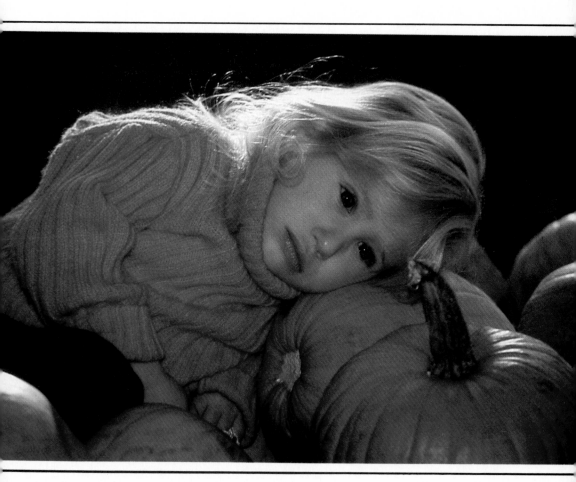

Keeping Track of Important Events

The first tooth, the first pair of real shoes, the first steps, the first birthday—all of these events and many others mark beginnings in your child's life. Photographic records of these events will be priceless to you when the children cease being children. A small, automatic exposure camera is handy for such events, especially since some of them can happen quite suddenly and without much prior notice. We have all seen pictures in family albums showing mom or dad holding junior up by his fingertips as he "takes his first steps"; but how many pictures are there of the moment when a toddler gets up unassisted and wobbles momward? Not many.

All this is not to suggest that you should plan your child's life around the photographs you want to make; but certain milestones of your child's life ought not to go unphotographed, even if the pictures are not made the very first time the events occur. Building a collection of pictures of events such as those mentioned above and placing them

A key to a picture like this is to get set where the action will be when you want to make the picture, not where it is when you first give the child the toy. Back off several feet and relax; sooner or later the ball may be kicked your way.

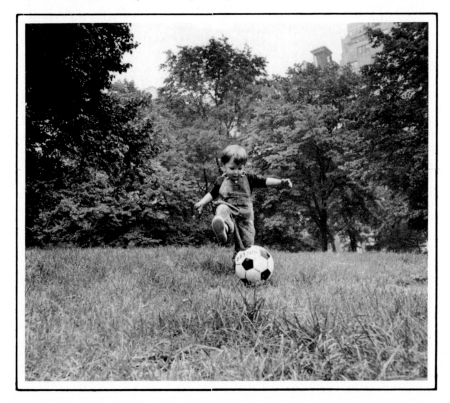

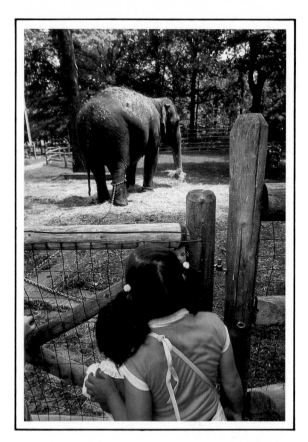

To keep both near and far objects in sharp focus, close your lens down to a small f-stop (f/11 or f/16). Photo: C. Child.

in chronological order will help establish a formal visual biography of your child. If you begin such a collection, keep records of when each picture was made—but keep the record separate from the photo album or book. Your album will look best if you avoid captions (except for the date) whenever possible—let the pictures tell the story.

Besides the standard firsts, there are a number of other events to photograph that might be meaningful later on—the first temper tantrum; the first pet; the first friend; the first time company comes, and so on.

These pictures need not be single images. Teething, for instance, might be better illustrated by a series of pictures showing the baby with a teething ring, then a piece of toast or a hard biscuit; followed by a photograph of the child smiling and showing off the new tooth. End with a photograph of the tooth being put to use on a piece of real food. Use your imagination to create stories with your photographs.

The project will probably look best if all of the photographs are the same size, and all are in either black-and-white or color. Imagine the album as you would a published book of photographs, and approach it the same way. With a little planning and work, you will produce a family document that both you and your children will treasure.

A Visual Diary of Your Child's Growth

Another project you might try involves photographing your child on a regular basis—at each birthday, for instance—leaving everything the same in each picture, so that your child's progress really stands out.

Equipment. If you are doing this kind of project with 35mm equipment, use a long focal-length lens and slow, fine-grained film. Also, vertical pictures are recommended. If you shoot horizontally, you will end up with an awfully long composite image in a short time. You can always crop the pictures or enlarge sections of them; but since this kind of project relies heavily on the physical quality of the prints, you should use as much of the negative as possible.

Rollfilm cameras producing 6 × 6cm images are perfect for this kind of work; the larger negative size enlarges beautifully, and the square format allows you to frame a face or head and shoulders in the most efficient manner.

Of course, these are merely suggestions—you might want to make full-figure pictures, for example, because your child has a unique way of standing or sitting; you might present the pictures one on top of the other, instead of from left to right. Use your imagination, but keep in mind that the simpler the shootings and their presentation, the more powerful the overall effect of the project will be. No matter how you decide to do it, your visual biography will give both you and your children more gratification and a better appreciation of the passage of time than will height markings on the kitchen wall.

Moods are as varied as activities; let your picture diary include that variety.

Use the poses the subject chooses naturally, they will be the most expressive.

Technique Tip: Keeping a Uniform Record

Approach this project as you would a portrait. Set up a neutral background, or find a place in your home that is not likely to change over the years. Set up lights or use bounce flash. Make a head and shoulders portrait or a full-face photograph each year at the same time, trying to get the same expression each time, for a record of physical growth, or letting your child respond as he or she wants, for a record of changes in mood or demeanor as time goes on.

Use the photographs you made the years before as reference for image size, placement, and lighting. Try to use the same camera type and lens each time as well—eliminate as many variables as you can. Have prints made that match in tone from shooting to shooting. Print them the same size, and lay them out side by side. After about five or six years of doing this, a remarkable thing will take place—you will see your child grow up in front of you.

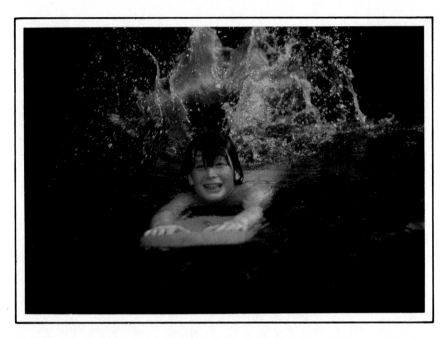

An activity like this frequently has a rhythm to it. As the child swims toward you, try to pick up the cadence of the splashes, Then when he's in camera range, you will be able to sense as well as see the right moment to release the shutter. Photo: T. McGuire.

Avoiding Cliches

A cliché in photography is any image that has been made so many times that it ceases to have any effect but boredom. Photographic clichés are usually not the fault of the subject matter, but of the way the subject has been dealt with. Child photography is full of them—look in any commercial portrait studio window and you are bound to see a few: the young girl in a leotard and toe shoes, head bent, and eyes closed; the chubby cherub looking up toward you, with a small bow in her hair and rouge on her cheeks; the baby holding a rattle aloft; the sartorially underprivileged infant sprawled on a rug. These pictures are everywhere, even though they have little to do with the people in them. These photographs fail as meaningful pictures probably because they are more adult suppositions about children than they are pictures that have something to say about childhood.

It is easy to avoid making trite photographs of kids. Simply approach children as you would any human photographic subject; observe them, find out their characteristics, their interests, their physical and emotional ways. Express an interest in them, without being patronizing or unnecessarily cute. If you show a genuine enthusiasm for them, they will more often than not open up to you, letting you see their inner person.

Concentrate on discovering the unique aspects of each child's personality, rather than making generalizations about all children; your photographs will be better for it. If you are photographing unknown children in a public park or a schoolyard, watch for a while before bringing the camera to your eye. Get a sense of the place you are in and the people there with you. See how they interact, and pick out specific episodes, incidents, and moments from the whole scene, rather than trying to make a photograph of kids playing. As with all other kinds of unplanned photography, making pictures of children having fun with one another will be different each time you do it.

The same is true when making child portraits or candid photographs of children at home. Let them make your pictures happen, instead of imposing your ideas on them.

A game of hide-and-seek is an excellent way to interest a child. Volunteer to be "it". You have only to hide in a spot the youngster is bound to find and wait for your picture to arrive.

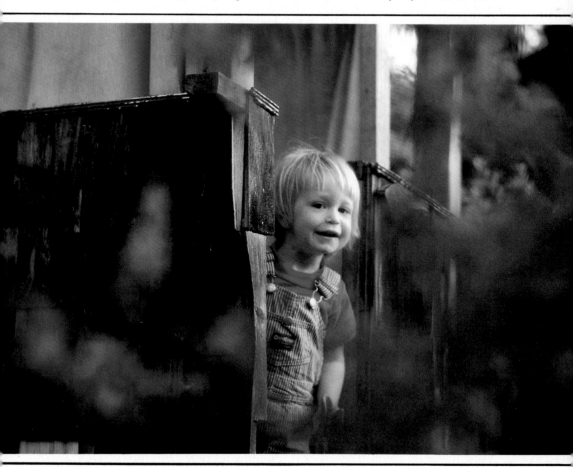

2

Preteens

The preteen years are the ones during which you will find the most opportunities for child photography. Grade-school children are involved in all kinds of activities, have found hobbies, belong to various social and religious organizations, and get into mischief. Many preteens have their own rooms, their own secret hiding places. They have best friends and favorite games. They are able to articulate their likes and dislikes and have developed distinct personality traits.

Environmental Portraits. Because of these things, the preteen years are an ideal time for environmental portraiture, i.e., in their rooms or in the playground, alone or in groups. If you can get permission, you might try photographing children in their school environment. Follow a group of students as they go from one class to another and put together a documentary of one day in the school.

Dealing with Adolescent Personalities. You will find that some children are absolute hams in front of a camera, loving the attention or simply being fascinated by picturemaking. Others, however, will be more wary of adults. These preteens have developed a large measure of self-consciousness, and have begun to erect masks that you will have to break down if you are going to make honest portraits or other confrontational photographs of them. You will have to work at getting them to relax in front of your camera. Outdoors, you will have to use equipment that allows you to stop motion and follow focus quickly. Long zoom lenses will enable you to maintain enough distance from your subjects to avoid interfering with their activities.

Many photographers carry a pocketful of inexpensive surprises to give the subjects something to do while they're being photographed and to promote a friendly atmosphere.

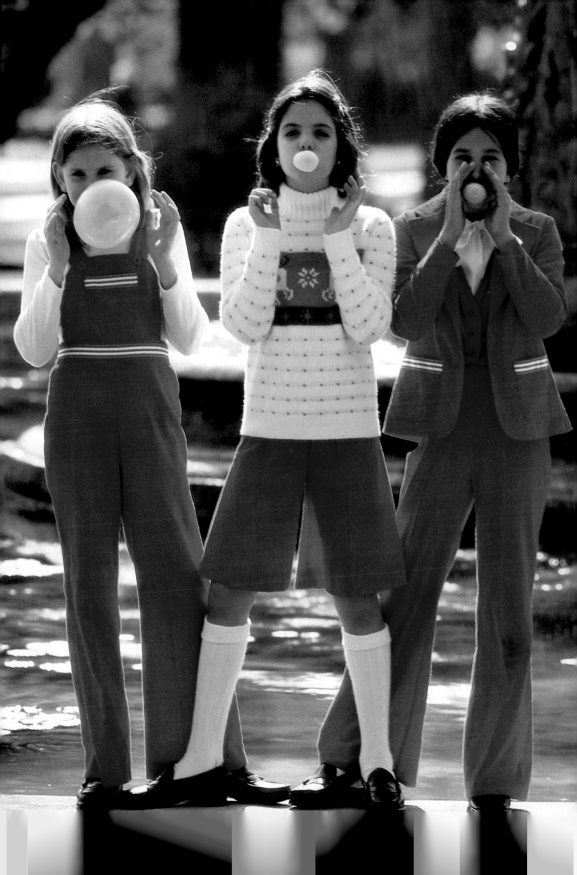

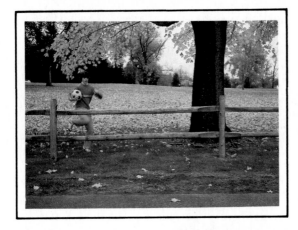

Always make sure there are plenty of frames left on the roll in your camera before beginning a picture sequence with a power film advance. It's preferable to waste the last few frames of a roll by reloading immediately, rather than run out of film at an awkward moment.

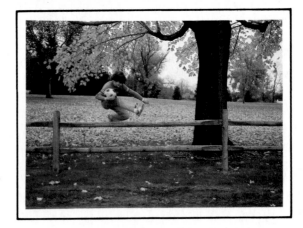

Learning to choose the best rate of power advance is a matter of experience. To save film, estimate the likely interval between important moments and set the power winder for that speed.

Keeping Pace—Photographing Active Children

At all age levels, you will find that some children are far more active than others. The passive children are a lot easier to photograph, since they will not disappear from your viewfinder unexpectedly. Use your standard lens from a moderate distance for three-quarter shots, then come in closer for tight portraits or closeups of specific actions (hands with crayon and paper; fingers on the piano keys, and so on).

Lenses. You will need a different approach with active children, however; someone running in and out of a room or bouncing around on a pogo stick can be very hard to keep in focus and properly framed if you use the techniques you used for photographing the less active child. For photographs of active children, use a long-focus lens that you can handhold comfortably, and step back. Use the fastest shutter speed that still affords you enough depth of field to compensate for any slight focusing errors you might make; for photographs that include the sur- roundings, use a wide-angle lens and move in closer—the extra depth

of field that wide-angle lenses provide at large apertures will let you use shutter speeds that are fast enough to diminish camera shake caused by moving to keep your subject framed and by shooting quickly.

On bright days, or when you use flash, you can use a moderate zoom lens (35–70mm, or, from a greater distance, 70–150mm on a 35mm camera) to give you the best of both worlds; focus at the longest focal length, then zoom back to show your subjects and their surroundings; then zoom in to capture individual expressions.

Practice panning with your zoom lens. Follow your subject and zoom until you can coordinate these actions smoothly. To pan with any camera lens, bring the camera to your eye, focus on your subject, and move your entire upper body in the direction of the motion, keeping your hand on the focusing ring to make small adjustments. Try to move at the same rate of speed as your subject is moving, to keep him or her located properly in the frame. Use a chest pod, or hold your camera as firmly as possible. If you are using your zoom at its longest settings, or if you are shooting with a long-focus lens, you can create an increased sense of movement by panning, because the background will streak out

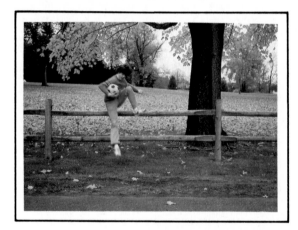

Often a sequence looks best when the camera remains fixed and action moves across the frame.

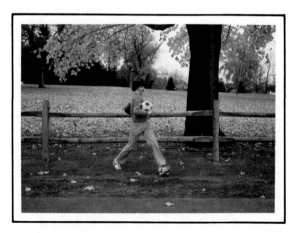

Leave the shutter button depressed for a few frames after the action has been completed to be certain of having a closing picture for your series.

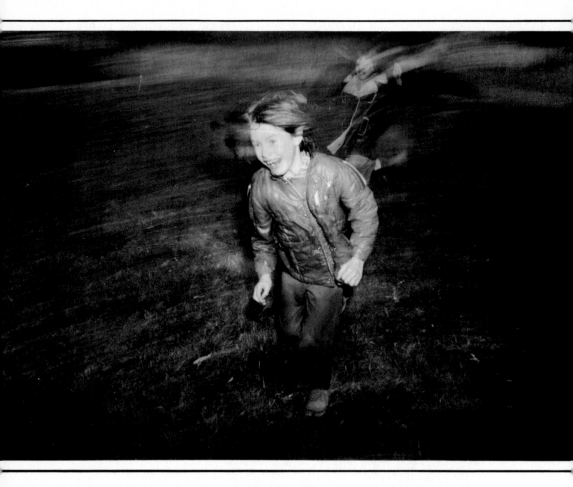

Using a flash unit can help keep pace with active children. Here a flash unit was used with a camera set at a slow shutter speed. The ambient light was bright enough so that the film was partially exposed (the blurred images), the flash exposed the child (sharp foreground image). Photo: M. Frank.

of focus as you move the camera. With shorter lenses, the effect is there, but it is usually less dramatic.

Exposure. If you are close to your subject, or if he or she is moving across the camera frame, you will need to use faster speeds than you would use with shorter lenses or if the child is coming toward you.

With a moderately long lens—85–135mm on a 35mm camera—use 1/500 sec., if your subjects are about 6 meters (20 ft.) away and running across your camera frame. If they are coming toward or going away from your camera position, use 1/125 sec. If they are moving at an angle to your camera frame, use 1/250 sec.

With a 50mm lens at 3 meters (10 ft.), use the same shutter speeds as described above. The same applies to a 35mm lens used at 2 meters (about 6 ft.). As your subject gets closer, increase your shutter speed.

If you shoot with an aperture-preferred camera, select a lens opening that will give you the speeds you need. If your lens is wide open, you will have to be very careful when you focus to keep the kids sharp.

Autowinders. Use your autowinder or motor only on those occasions when you really need it—you may run into the problem of "shooting between" the pictures you are after. It is easy to assume that the fast firing rate some winders give you will let you capture everything that is going on. If you are not careful, however, you might miss. Remember that as the exposure is made, the mirror in an SLR camera flips up, temporarily cutting off your view of the subject. If you are photographing a child making a repetitive movement—jumping about on a pogo stick, for instance—make sure that your winder/camera combination goes off while your subject is either at the top of a jump or at the end of it; photographs you make showing the activity in between its peak moments will rarely be as interesting.

Here a flash unit created all the light to expose the film. Note how the water droplets are sharply recorded. Photo: M. Frank.

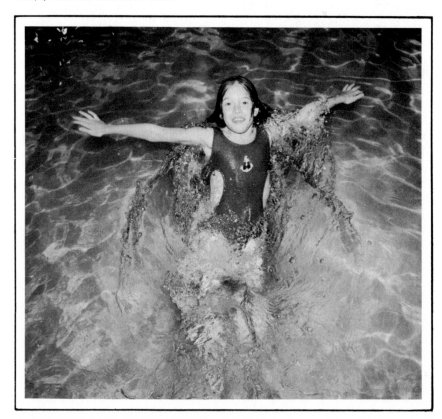

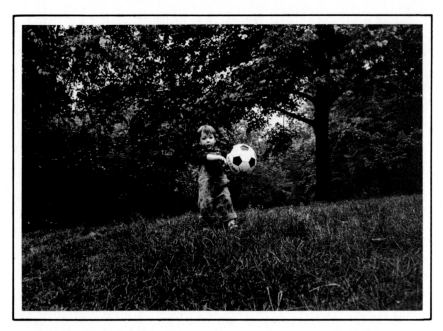

One way of lowering your eye level to that of your young subjects is to stand on lower ground. This gives you a child's perspective of your subjects without having to bend over or kneel down.

Seeing the World From a Child's Point of View

It is a good exercise, photographically speaking, to acquaint yourself with the environment of your subjects. Many photographs of kids do not work as well as they might because the photographer did not do this. If you photograph children from up close and remain standing at your full height, especially if you are using a standard or wide-angle lens, you will get large-headed children with tiny feet. With standard lenses at distances of 1.5 meters (5 ft.) or so, the effect is slight enough not to be noticed in the viewfinder unless you look for it; but you will see it right away in your pictures.

Shooting at Child's-Eye Level. To get more lifelike pictures of children at close ranges, you will have to bring your camera to their eye level. The taller you are, the more tiring on your back this can be if you use an eye-level camera. However, if you get close to the ground with your eye-level prism, you will be able to make pictures of the world the way children see it.

If you have a child of your own, watch the way he or she moves about the house, and pay attention to the size common household objects seem to have for your child. You might try a photographic series showing a normal room as it appears to a youngster: To very small

children, chairs and tables look huge; the back of a chair looks further away than it does to grownups; countertops are barely within reach. If you move around at child level with a wide-angle lens on your camera, you will be able to simulate the size and distance difference. You might make a few pictures of your spouse from child-level, then ask your wife or husband to do the same for you, so that you both will have a visual representation of how you appear to your child.

Waist-Level Viewfinders. If your camera accepts interchangeable finders, get a waist-level one; lengthen your camera strap a bit, and make pictures from your subject's natural height. You will find that waist-level finders on 35mm cameras are difficult to focus with when you use wide-angle lenses or shoot in dim light; most are equipped with flip-up magnifying eyepieces to make focusing easier; but you have to bring the camera to your eye to make use of it. Waist-level finders also present you with a wrong-way-round image; objects on the left in real life will appear on the right in the finder. This laterally reversed image makes it difficult to photograph moving kids—if your subjects are active, use your normal prism and squat.

Because of these problems, using a waist-level finder will not be so fast as the normal method; but it will solve the distortion problem.

If your camera does not accept interchangeable prisms, it may accept a right-angle finder attachment. This works the same way as a waist-level finder, but must be used with your eye near the camera eyepiece.

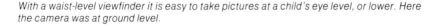

With a waist-level viewfinder it is easy to take pictures at a child's eye level, or lower. Here the camera was at ground level.

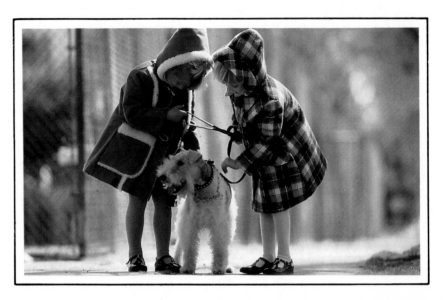

Gaining Their Confidence and Keeping Their Attention

Small children, up to about age five, are usually not going to be too concerned with you as you photograph them, as long as you act cheerful, friendly, and interested in what they are doing. If they show you something, or ask you to participate in whatever they are doing, put your camera aside for the moment and join in. Small children's games are generally invented as they progress, thus giving you an insight into your subjects. Wait until the children are engrossed with his or her plaything, and make your pictures in between the tasks the kids give you. In a while, they will probably continue their playing without you, even though you may be sitting with them. At this point, you will have become familiar enough to them to photograph unimpeded.

Preschoolers. If you wish to make closeups of strange children that are in a park or playground, for instance, ask the parents' permission; then go over to the kids, ask what they are doing, and find out their names.

If you want a frontal shot of the children, say their names, then ask a question that has something to do with their activity. If you keep talking as you get your camera ready for the exposure, they will be less likely to respond to the camera in an unnatural way. Whenever possi-

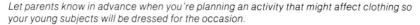

Let parents know in advance when you're planning an activity that might affect clothing so your young subjects will be dressed for the occasion.

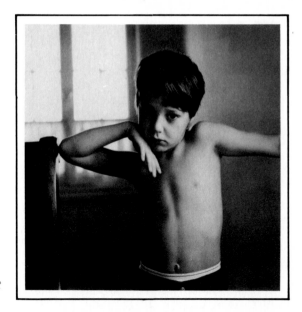

Allow the children you photograph to express their emotions freely. In some circumstances, giving up a planned activity and letting events take their own course will produce the best pictures.

ble, focus while the child's attention is elsewhere, so that your camera is in front of your face for as little time as possible while the child is looking at you.

Pre-Adolescents. Keep these same considerations in mind when dealing with children up to about age eight: Let them take the lead in the game or activity, and engage them in conversation about what they are doing. At this age, children are voluble, and enjoy explaining their games. Allow them to demonstrate their toys; photograph them as they do so, and as they talk to you. A waist-level finder will be a big help— you can maintain eye contact with the child, looking down into the finder only to make sure everything is framed properly.

The fastest way to gain the attention and confidence of most ten-year-olds is to show them some skill you have that they can learn quickly—demonstrating a simple card trick, a fancy knot that is not difficult to tie, or some other such skill will earn you their respect and interest. If they ask questions about the camera or what you are doing, answer them in a way they can understand. After you have made a few pictures, let them look through the viewfinder (do not let go of your camera strap) and show them how to make photographs of one another.

Adolescents. Children over ten years of age can be coy, self-conscious, or uneasy in front of a camera, especially if they are aware that you are singling them out for photographing. Again, you will find it easier to photograph these children if they have an idea that you are interested in who they are and what they are doing or thinking. Spend some time being diplomatic, and you will come away with better pictures.

When a youngster is proud of a skill, encourage her to demonstrate it for you. Expressing your respect for an achievement is a sure way to gain cooperation.

Everyday Activity—Children at Play Outdoors

Children under five spend most of their playtime acting out their own fantasies, with or without toys or other props. They usually play in small areas, or let off steam by running around in a seemingly arbitrary way. Usually, though, the running has some sort of pattern—a distorted circle or figure eight. Watch such activity for a while. You may observe that at a certain point the child extends his or her arms or jumps, or makes some other expressive gesture; such gesturing often repeats. If you do spot a repetitive action, prefocus on a spot, and be ready when your subject passes it. If there is no apparent pattern to the movement, step back and close down your lens so that you will have enough depth of field to get a sharp picture even if the movement occurs too quickly for you to get precise focus.

Quiet Play. Slightly older boys and girls play with their toys more formally—they play with dolls, figurines, small cars, and so on, and the play is more organized. With a long-focus lens from 2 meters (a few yards) away, you can pick out the interesting parts of the game or interaction between kids without getting in their way. Walk around the area they are using to find the most interesting view.

Organized Games. Kids older than eight play organized games with set rules and specific skills—jacks and hopscotch are two timeless favorites needing little space. Set yourself, with a zoom lens, far enough

away so as not to make the children feel as though they are on display for your camera, but close enough to get head and shoulder shots or other closeups.

At a game like hopscotch, take a couple of turns with the kids (if they want you to); when you are done, they probably will not mind your photographing them from close-up. For a less conventional view of a hopscotch game, or of skipping rope, use a wide-angle (28 or 24mm) lens on your 35mm SLR (single-lens reflex) with a waist-level finder; hold your camera over the heads of the kids, and point it at the playing area. If you hold the camera "upside down," you will be able to frame the image while the camera is outstretched.

Again, using the wide-angle lens, place your camera at ground level, filling the bottom edge of the frame with the end line of the hopscotch board. Wait for one of the children to start, then make pictures of the movement across the field. The wide-angle lens will give a stadium-like appearance to the play area—your first shot will show a little person in the background; the other pictures will have the person growing larger and larger as he or she approaches the end line. The closest shot will show two giant but definitely childlike legs looming into the foreground of your photograph.

Photograph your kids as they leave the schoolgrounds and play with one another on their way home. The easiest way to do this is from across the street or from behind them, with a long-focus lens.

By standing slightly above your subject and tilting the camera downward, you can effectively turn the ground or water surface into a pleasant background.

Groups of Children

As with any group pictures, photographing groups of children is more difficult than making pictures of one or two at a time. If the pictures you are making are informal, i.e., they are not aware of you, the only added difficulties will be technical—you will have to use a wide-angle lens or work from a reasonable distance to get all of them in the frame. This makes it difficult to examine individual expressions. If you opt for a wide-angle lens used close-up, you will be able to look at your subjects normally, peering at your viewfinder and framing when the time is right; however, the kids closest to the edges of the frame might come out distorted, especially if they are leaning out of the picture. Children in the immediate background will appear smaller in relation to the rest of them.

A long lens used from further off will make the background kids appear closer, but they will be almost the same size as the ones in the foreground. If there is some game going on that involves throwing a ball or a Frisbee, the wide-angle approach will be better—the exaggerated perspective will add to the feeling of throwing and catching an object.

If the kids are doing something more sedate together—caroling, swimming in the pool, or milling around outside of their classroom, the long lens will make them appear to be a more closely knit group. Make your lens choices based on the kind of activity your subjects are indulging in.

Technique Tip: Formal Portraits

For group portraits in formal situations, you will have to come up with a way to keep the children from fidgeting or looking away. Talk to them; ask them questions and have them shout out the answers to you (make the pictures as they think) or ask them all to close their eyes as tight as they can. They will usually face you as they do this. Make a picture of them while their eyes are closed—it might turn out to be the best one of the session, especially if you find that one of the more mischievous kids is sneaking a peek. When you tell them the picture has been made, and they open their eyes, immediately take another picture. The shooting will take on the aspects of a game in which you repeat the procedure as they try to catch you in the act. You may miss a few frames because one or another of the children moves, but you will have gotten their undivided attention long enough to come away with the photograph you were after.

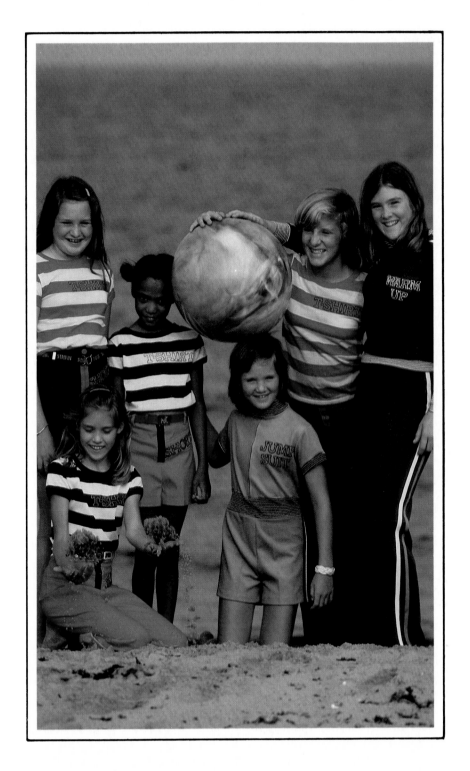

A light-hearted touch—like a beach ball on a head—can be a nice complement to an informal waterside portrait.

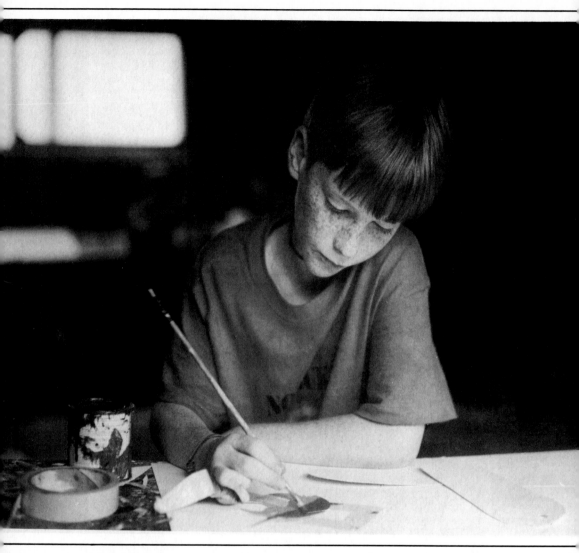

For proper exposure in existing light with a dark background, bring the camera up close to your subject. Take your reading, lock it in, and move to your picture-taking position. Photo: T. McGuire.

On Location in a Child's Room

If the children you are photographing have their own rooms, you might find the setting to be perfect locations for portraits; or the rooms themselves might be interesting as subjects. In either case, ask the child for a guided tour—find out which are the favored toys, and if these have

their own special locations in the room. Be curious about everything, but let your subject take the lead. As you get led around, make light readings and notice how shadows fall so that you can prepare for the portrait session more completely. Your best pictures will usually be those you make with existing light—childrens' rooms are usually small and bright, so handheld exposures will not often be a problem. Use fast film and a moderately wide-angle lens; if the room is very small and can be covered only with an extreme wide angle, use a tripod and keep the camera level to minimize distortion.

Lighting. If the lighting is poor, see if you can put tungsten bulbs in the fixtures, but be careful not to burn lampshades. Make sure that your color transparency film balances with the light source. Use tungsten-balanced film with an 82B filter for 100 W (Watt) incandescent bulbs, or an 82C filter for 75 W incandescents. Both of these filters require an extra $\frac{2}{3}$-stop exposure, so set your exposure compensation dial, or adjust the camera's film speed dial accordingly.

If you are shooting by light coming in through a window, use daylight-balanced film and keep the roomlights turned off, if possible. Failing that, bounce electronic flash light off the ceiling to flood the room with day-balanced light.

If you are shooting with black-and-white or color negative film, you need not be concerned with anything but the intensity of the light. Let your subject get used to your presence in the room, and wait for him or her to assume a comfortable position in his or her favorite part of the room.

Be Unobtrusive. If your child leaves the door open as he or she plays inside, does homework, or whatever, take a camera and quietly make pictures from the doorway while the youngster is engrossed. Use a long focal-length lens, and a chest pod; or brace yourself against the doorjamb for support. Flash will ruin the effect, since your subject's attention will be diverted, so make your pictures by available light.

Unoccupied Rooms. A child's room can be excellent material for a portrait of its owner, even if the owner is missing. Make closeups of the child's toy arrangements, take still-lifes of the collections of objects your child might have picked up; photograph half-finished drawings with the pencils or crayons still out. For these pictures, use the finest grained, sharpest film you can; mount your camera on a tripod, and bring in a photolamp or two, if needed. These pictures will bring back memories for both of you in years to come. Sometimes a picture of a beloved toy, or a long-forgotten object will bring back feelings of childhood more strongly than even pictures of the child's face will.

3

Special Events

Recording the special events in a child's life is to some degree like establishing a formal history of his or her existence. Most child photographs are of this nature; most of us have pictures of ourselves at christenings, Bar Mitzvahs, graduations, birthday parties, and so on. Making these pictures is easy—the child who is performing a ceremony or is involved in a birthday party, will be too excited and engrossed in the goings on to care whether you make pictures or not.

For most formal situations, planning is the key to success. Because events like christenings, plays, and sporting events take place in public locations, you can check the lighting and your best picturemaking positions beforehand. You can introduce yourself to the administrators of the event, and ask where you can and cannot shoot from during the activity.

For any such event, make sure you bring with you everything you need, including extra batteries, lens tissue, appropriate filters. And as with any location shooting, do as the professionals do—bring twice as much film as you think you will ever use.

The informal activities—indoors and out—require less prior planning and little or no special equipment or technique. You will find the same picturemaking problems as you do in other child-photography situations, though the choice of things to photograph will be different.

In addition to birthday parties and graduations, there are other less formal times in a child's life that may be considered special events and worthy of recording—holidays out of town, trips to amusement parks, zoos, or county fairs, and participation in or observation of sporting events. Whatever the event, there will no doubt be unique photographic problems as well as possibilities.

Before giving a child any sort of toy or candy, always check with a parent or guardian before the youngster sees the treat. The request needn't be elaborate; a simple gesture is usually enough. Photo: H. Hoefer/Apa Productions.

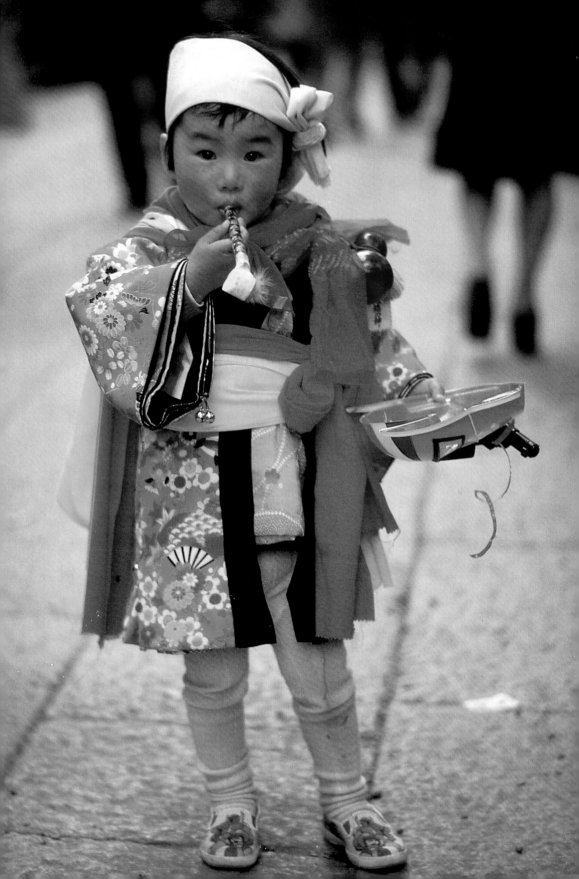

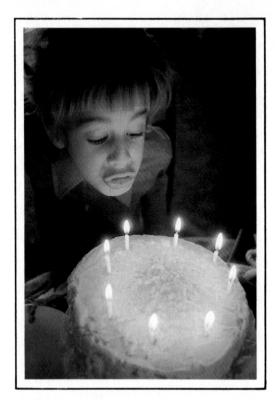

In this picture the cake acts as a reflector, warming the subject with the redness of the candle-light. Photo: M. Heiberg.

Parties

Children's parties are usually at least as much fun for the adults who plan them as they are for the kids in attendance. Show this in your pictures by photographing the preparation of food, the hanging of the decorations, the wrapping of presents, and so on; then continue to make pictures of the adults enjoying themselves along with the children.

Indoor Parties. If the party is indoors, you will be best off using a small electronic flash unit for light, preferably bounced from a ceiling or wall, or diffused (softened) with a piece of lens tissue taped over the flash lamp. The children will be too busy having a good time to care about the flash light, and if they are over three or four, they are used to the fact that parties get photographed by older people.

Act as the observer—do not ask kids to take time away from each other to pose for you, or to do something they are not doing at the moment. Pay attention to the way they respond to the food they are served, and to how they unwrap their presents. Do they undo bows neatly and unfold the paper, or do they rip into everything, eager to get at what is inside? Most kids are of the latter persuasion. Photograph the temporary looks of frustration as they struggle with a knot

that refuses to untie or a box that will not open; then photograph them handling their new prizes for the first time. These pictures can be made with your long focal-length or your standard lens; save the wide angle for shots of all of the kids at the table, or for group games they might play later on.

If you are shooting in color, be aware that light from birthday candles will appear extremely red on tungsten film. If you are using flash, with daylight color film, the flash light will provide most of the exposure, and the candlelight will not appear overly red.

Even though the idea itself is something of a cliché, make pictures of the boy or girl blowing out the candles—each child's face takes on a wonderfully intense expression as he or she concentrates on this task. If you have a zoom lens, you will be able to get a quick picture of all the guests at the table watching the candles being blown out, and another closeup of the child's face hovering over the cake.

Outdoor Parties. Outdoor parties will allow you to make your pictures from further away, with longer lenses or at smaller apertures. If the party is taking place in a garden or on a lawn and the sun is bright, use slow color film (ISO/ASA 25), to capture the greens; and a polarizing filter turned to its darkest setting for the sky, to increase the saturation of the blue. The combination of deep green grass, rich blue sky, and colorfully dressed guests will give you an exceptionally vivid record of the event.

A feeling of unity is gained when all of the children in a picture are paying attention to one activity.

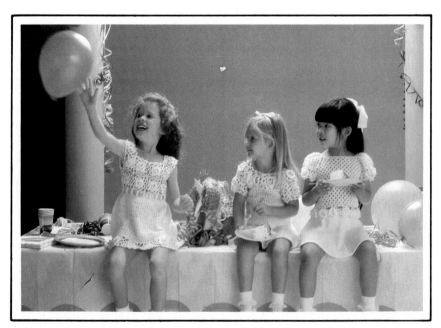

Performances and School Events

If you want compelling pictures of kids performing in a play, attending school dances, or taking part in some other organized school activity, you should get ready for your shooting in the same way you would for adult versions of the same affair. You will need slightly different equipment and techniques for each of the situations described above, and you will be better guaranteed of success if you do a little careful planning beforehand.

If someone hired you to make pictures of a professional dramatic production, you would attend rehearsals so that you could get to know the performance. You would know the length of each actor's dialog and song. You would know when to expect changes in lighting. You will need to know the same things for photographing a school play. Even though the production of one of these might be a bit less lavish than a full-fledged theater performance, your preparedness needs to be just as thorough.

Dress Rehearsals. The best time to photograph stage performances, adult or otherwise, is during the dress rehearsal. The lighting, costumes, and so on will be the same then as they are during the actual performance, but the actors will usually be less tense. Also, certain difficult scenes or musical passages might be rehearsed several times, giving you a chance to capture pictures you might have missed the first time around. Since there is little or no audience during the dress rehearsal, you will not run the risk of becoming a nuisance as you move around to find the best vantage point for your pictures.

Technique Tip: Planning Ahead for Stage Shows

The two most important aspects of photographing stage performances are the placement of the actors and the lighting. Talk to the stage manager or director and the person responsible for the lighting, and see if you can get copies of the physical layout of the scenes, so that you will know where to be and which lens(es) to have on your camera(s) for the best pictures; get lighting diagrams and a timetable, and plan your exposures beforehand. If you use automatic exposure cameras, your job will be that much easier, but it will still be helpful to know when major changes in illumination are going to happen, so that you can be ready with the right f-stop or shutter speed just before the lighting change happens. This way, you will be able to concentrate on the performance (your subject matter) rather than on camera settings.

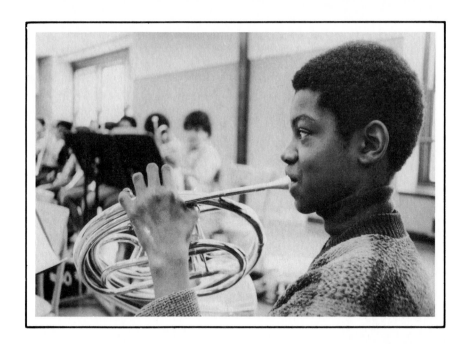

When photographing a music rehearsal, try to find camera angles that do not interfere with the performers. Remember that they need to see the conductor. Photo: B. Goldberg.

Lighting. Theatrical lighting is usually quite bright, allowing you to use reasonably fast shutter speeds and moderate apertures with medium- or fast-speed films. Many beginners make the mistake of trying to take light readings from the audience's viewpoint; if you do this with most cameras or handheld exposure meters, you will include too much of the darkened theater in the reading. The usual result of this is overexposed pictures. If you can, make the light readings from the stage, during the lighting check (this usually occurs some time before the dress rehearsal, so get there early). Make notes on the readings, and be ready when the performance begins. If you must make your readings from the theater itself, and you are using a through-the-lens exposure meter, use a long focal-length lens so that you read only the important parts of the scene.

Shooting from the audience's viewpoint will require the use of long lenses anyway, so you will rarely run into the problem of metering with one lens then having to shoot with another. Of course, if you do make your light measurements during the lighting check, you will have plenty of time to note them, then be prepared with the proper optics for the photographs when the time comes.

Color Balance. If you are making your pictures in black and white, the only thing you really need to be concerned with is the amount, or intensity, of the light at each point in the performance. Color photography in theaters, though, poses a different set of problems than it does under many other conditions. Stage lighting is often colored in such a way that accurate skin tone is difficult to get. If the flavor of the scene is what you are after, use color negative film, or tungsten-balanced transparency film. In the former case, changes in tone can be made with filters when prints are made; in the latter, tungsten-

Use a medium-long lens to pick up one or two people out of a large group. That will give you enough camera-to-subject distance to avoid distracting the performers. Photo: J. Child.

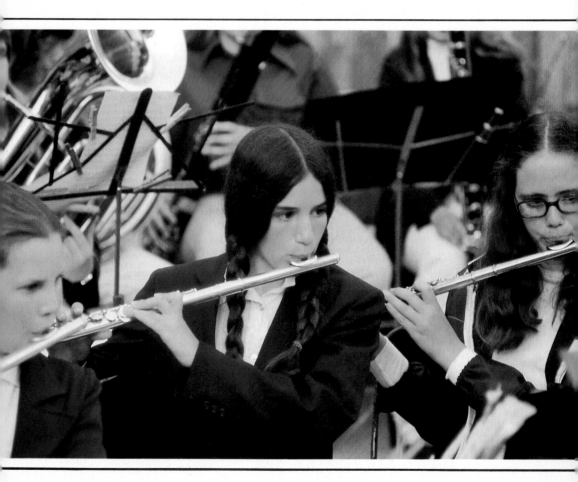

balanced film will be closer in color temperature, or balance, to the theatrical lighting. Often, the spotlights on the performers are close enough in balance to that of your film to give you reasonably good skin tones, even if the rest of the scene is illuminated in red, blue, or another deep tint.

The person in charge of lighting should be able to tell you the color balance of the lighting for the performers. If you are told that the spotlights on the performers are balanced for 3200K, use tungsten films with no filters. If the lights are 3400K, place an 81A filter over your lens, and give $\frac{1}{3}$ stop more exposure. If your camera has a through-the-lens exposure meter, the exposure change will be indicated without your having to make the adjustment. If the lighting on the performers has a strong color cast, forget about trying to get proper skin tone—the play calls for a certain color cast on the actors, and your pictures ought to reflect this.

Photographing Actual Performances. Making pictures in a theater during a dress rehearsal can be done with just about any camera you feel comfortable with, and can use quickly. Photographing during live performance, or making pictures of a musical recital, will disturb both the performers and the audience if your camera is not particularly quiet. For this reason, and because some people do not realize how disturbing the use of electronic flash can be, many theater managements forbid the use of SLR cameras during a performance. People running school productions might be more lenient about the camera, but most will not allow you to use flash—nor should you, since the light might interfere with the performers' vision. Besides, the light quality of electronic flash will look nothing like the lighting used in the performance; and the stage lighting is an integral part of each scene.

If you have to make your pictures during a live performance, do so with the quietest camera you can find.

Dances and Proms. The lighting at school dances, proms, and the like will usually require the use of fast films and lenses for available light pictures. In most cases, you will be able to shoot your pictures with electronic flash; if this is the case, use a medium-speed daylight-balanced transparency film. Bring a standard focal-length lens for shots of couples dancing or talking, a wide angle to include all of the people on the dance floor, and a moderately long lens to pick out individual faces, or to make your pictures of couples from an unobtrusive distance. A wide to moderately long zoom lens (35–70mm or so) is a good tool for this kind of photography, since it will allow you to get a variety of perspectives and viewpoints without having to change lenses.

Social gatherings such as these are perfect places for making records of the awakening interest of kids to members of the opposite sex; and of their response to the kind of social activity adults indulge in.

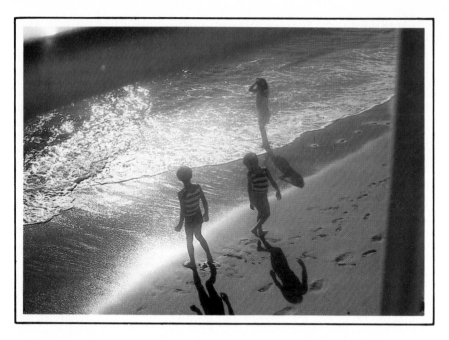

You needn't be in the same space with your subjects to photograph them. Fine picture opportunities are often presented by the combination of an overlooking window and a long focal-length lens.

On Vacation

Photographing your children while on holiday is in many ways easier than making pictures of them at home. For one thing, you will generally be seeing them responding to their surroundings in a more intense way, so their characters will come across more readily; for another, you will be more relaxed and aware of the surroundings yourself, since you will temporarily have put away your daily stresses of work and home life. Recording the way your kids see the places you visit might even give you a perspective on the locale that you might not get otherwise.

Children are not as societally restricted as most adults—their curiosity and sense of wonder is more intact; and once they have embarked on an adventure such as a vacation, their sense of enthusiasm can be boundless. Photograph them as they encounter things and places they have never seen before; record their responses to new people. If you are visiting a foreign land or a place of great natural beauty, try to avoid making picture postcard photos with your children as part of the scene. A photograph of your child with Mount Rushmore in the background will more than likely end up looking like a picture of Mount Rushmore with your child looking out of place in the foreground. Keep your tourist's eye separate from your child-photographer's eye, if you can; it will improve both your scenic pictures and your child photographs.

If you are staying in a place where there are other children present, you will have a perfect opportunity to make pictures of your children meeting new acquaintances. Keep back, use a long focal-length lens (135mm or thereabouts), and record the meeting without being intrusive. If the children are very small, you will not need to be so careful, since they will usually not care about your camera; but for older kids, the easiest way for you to put a damper on a budding friendship is to butt-in with a camera. If you have a twin-lens-reflex camera, or if your SLR has a removable prism, you can easily point the camera at the children while pretending to look elsewhere—keep the camera at your waist, and frame the picture by looking down into the screen. If the kids are engrossed in one another, they will not notice your little subterfuge.

Be mindful of customs in foreign lands; some cultures have certain taboos about photography. Most good travel agents and books on the area will describe these; you can avoid a lot of trouble if you get to know them beforehand.

Photographing a Day in the Life. You are not going to have much of a vacation if you spend the entire time framing your children through your camera lens. You can avoid this by setting aside one day to document your kids' response to the holiday. You can then enjoy yourself, taking pictures of your own responses to the holiday, while still being ready to photograph your offspring when they do something particularly memorable.

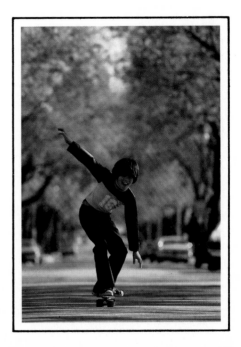

Dressing a child in brilliant colors will help her to stand out vividly from the subdued background tones of overcast days.

Sports

Children's organized sports should be photographed the same way that adult sports are. The equipment needed is the same, since most of the sporting events and the areas they take place in are identical to the adult versions.

Individual Events. Individual sporting events, such as gymnastics, diving, and field events, all usually require the use of long lenses and fast films. A good tripod is a must, and is rarely a hindrance in this type of activity since you will usually be shooting from one position. Each of these events is characterized by a peak moment—the moment when the young athlete is momentarily still while fully extended. In the case of the vaulter, there is a split second during the body's travel when the upward motion has stopped and the downward motion has not yet begun; the same is true of the diver at the top of his or her dive, or at the end of each change in body position on the way down. Leaps and turns made by gymnasts during floor exercises also exhibit these peak moments; javelin throwers are almost still just before they unleash their missiles; and so on. These are the best moments to make photographs of sports action; the athlete best expresses the dynamics of his or her sport just before the climactic moment.

Because sporting events happen quickly it's a good idea to keep your lens trained on the subject the entire time. For example, in a race, continue panning with your subject after the child has passed your position. Photo: T. McGuire.

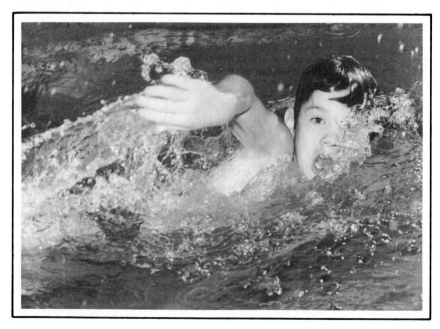

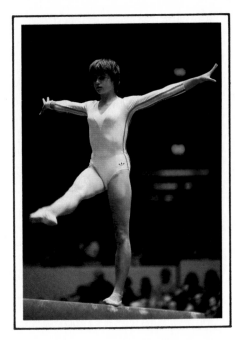

Some sports have routines that are repeated almost exactly from rehearsal to performance. By arriving early at the arena, you can spend some time studying the athletes practicing and decide in advance on the best camera angle.
Photo: B. Bennett.

To make good photographs of individual sporting events, you should get as close to the arena as possible, and attend practice sessions so that you can get to know the routines involved. Some events will be easier to record than others. The pole vault, for instance, can be easily photographed with a moderately long lens from somewhere near the crossbar. To make an effective picture of your child clearing the bar, mount your camera on a tripod, frame the shot to include the crossbar and enough space above it to include all of the vaulter's body, and prefocus on the bar. Set a small enough lens opening to render the vaulter sharply, use a fast film, and release the shutter just a fraction of a second before the peak moment occurs. You will not be able to see this moment in the finder of your SLR camera, as the mirror of your camera will be in the up position. If you can see the peak moment, you have missed the shot.

What is true for pole vaulting is also true for the javelin throw, though in this event there are two peak moments. One occurs when the athlete has the javelin all the way behind him or her; the other just as he or she releases it. Unlike the pole vaulter, though, the javelin thrower, the diver, or any other athlete who moves constantly, is best photographed by panning the camera. If you try to register a fast-moving athlete with a stationary camera, you will fail: The subject will blur across your picture frame and register the movement without indicating the activity. If this is what you want, fine; but most of the time, you will be more interested in recording the individual in the event, not the motion the event creates.

Technique Tip: Follow Focusing

To get an effective picture of a moving athlete, you will have to smoothly move your camera with the athlete, keeping him or her in one part of your picture frame at all times. You will also have to get used to the idea of moving your camera and focusing the lens simultaneously. With a lot of practice, follow focusing will soon become second nature.

The best way to photograph an athlete in motion is to pick a spot where you expect the peak moment of the action to occur. Frame the athlete in your camera's viewfinder before this area is reached, and follow the subject's motion smoothly with the camera. Just before the moment you want to record, gently begin depressing the shutter, keeping the camera moving. When the shutter has released, continue moving your camera. This follow through is as important in sports photography as it is in the sport itself.

Depending on the event, the speed of the athlete, and the amount of blur you want in the background, you can pan at shutter speeds from 1/1000 to 1/30 sec. and still get sharply rendered subjects. If you are close to the action and are using a moderate-length lens, you can do all of this handheld; extremely long lenses will require the use of a tripod, to ensure that you do not shake the camera.

Team Sports. Team sports are usually less controlled and predictable than individual events. If you are photographing children in a football, soccer, or baseball game, you will need long lenses, the fastest film you can find, and a sturdy tripod. If your lens is especially large, it might have a tripod connection built into its barrel. If this is so, attach the tripod to this rather than to your camera, or the weight of the lens might damage the camera's lensmount. Even if no damage occurs, the lack of good balance will cause lens shake during your exposures, and you will never be guaranteed of getting sharp results.

Usually, soccer and other continuous action games are best covered from one of the end lines. The most interesting parts of the action will generally happen where scoring is to take place. Sports like football, where the meaningful action can happen in various places, pose more of a problem; you will have to be ready to move up and down the sidelines to catch the action where it occurs.

If you are using 35mm equipment, you will find that a zoom lens (about 80–200mm) and a 300 or 400mm lens for closeup shots of the goal area or for extra reach into far areas of the field will render the pictures

you desire. If you use rollfilm cameras, your lens choices will be more limited. Prices for zooms or extremely long lenses for rollfilm camera equipment are astronomical. Unless you plan to make your living as a sports photographer, borrow someone's 35mm camera and lenses to photograph your children's sporting events.

Sideline Activities. Make pictures not only of the action on the field, but also of the young players talking with their manager or coaches; of the intensity on their faces as they experience success or defeat; and of the exhilaration and fatigue that intense physical activity creates. Attend practice sessions, so that the players and coaches get to know you. Above all, get to know the sport you are photographing; otherwise, you will never be able to anticipate the most photographically interesting moments of the event.

The drama of an athletic game is more than just a collection of climactic moments. Sometimes the anxious tension on a young player's face before an action makes the best picture. Reach out with a telephoto lens to get it.

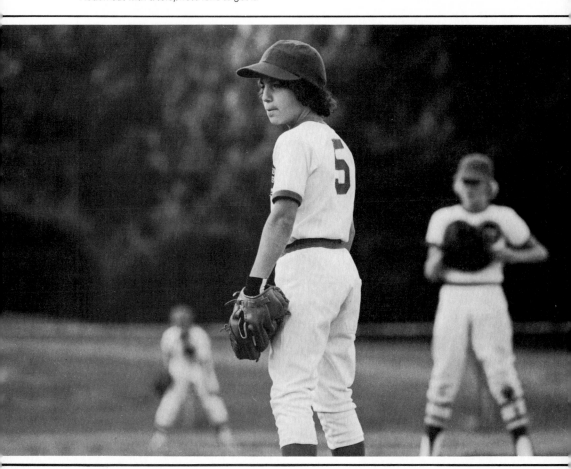

Ceremonies

Moments such as graduations, christenings, and awards presentations are milestones in a child's life, and thus worthy of good photographic documentation. Most of these ceremonies are ritualized and planned in advance, so you will not be dealing with the unexpected. Almost all ceremonies are rehearsed at least once, allowing you to make decisions about your camera position, lighting requirements, film, lenses, and so on, well before the actual event.

Religious Ceremonies. Each ceremony will have its own restrictions on your photographic freedom. This is especially true of religious ceremonies, where your dashing about, camera in hand, might be considered disrespectful, if not annoying. If the event is a purely religious one, you should check with the minister, rabbi, or priest to find out when you can and cannot photograph; whether or not you can use electronic flash, and so on. In most ceremonies, there will be a time when photography is allowed.

Social Ceremonies. Social ceremonies—graduations, ceremonies arranged by such organizations as the Boy Scouts, and so on—usually

Costume pageants are among the most delightful photo opportunities. Colors are usually bright and showy, and the children enjoy the chance to "dress up" in something different from their everyday clothes. Photo: H. Weber.

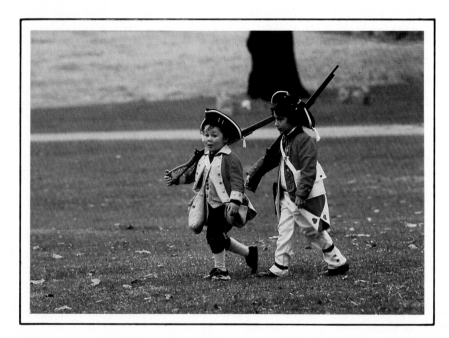

Even though you're photographing indoors, if your light source is daylight coming through a window, use a daylight type film for correct color rendition.

take place in public gathering places. Often they occur on stages or in halls, where there is light where you need it most—on the children in the ceremony. With ISO/ASA 400 film in your camera, you will usually be able to make your pictures handheld, in the existing light. If you are photographing in black-and-white, you may need nothing more than your camera, a moderately long lens (85–135mm for 35mm cameras), and a small tripod or accessory flash unit just in case. If the lighting is fluorescent and you are photographing with color transparency film, you will avoid getting a sickly-greenish cast in your pictures if you use daylight-balanced films and overwhelm the fluorescent light with electronic flash. For better non-flash color quality use a fluorescent light conversion filter. Place an FLD filter in front of your lens for daylight-balanced film, or an FLB filter for tungsten-balanced emulsions. Neither of these filters will give you perfect color rendition, but they will get rid of most of the greenness.

Using Flash. In most cases, no one will mind if you use electronic flash at a social ceremony—most such events are in celebration of some kind of achievement, and people are only too happy to have it recorded.

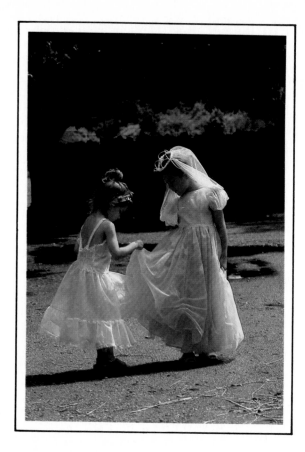

The electronic flash will override the fluorescent illumination, and give you good skin tones. Make sure, though, that your electronic flash unit is powerful enough to illuminate your young subject properly from your camera distance; if you are situated more than 4.5m (15 ft.) from the event, a small flash unit might not give you enough output for proper exposure. Check the dial on the back of the flash unit to see how far it will throw its light properly, and do not go beyond its limits. Better yet, borrow a more powerful flash unit from a friend, or rent one from your camera store; this way you will have more flexibility.

The Peak Moment. Like sporting events, most ceremonies have a "peak moment"—a handshake, the passing of an award, the pouring of water over the head at a christening, and so on. Almost all of these activities take place slowly and with enough forewarning for you to be ready. Get as close to the "core" of the event as you can. Make photographs not only of the godparents and minister or priest around the child at a christening, but get in close and also photograph the act of the christening itself: the child's head and priest's hand filling the frame as the oil or water is administered. At the presentation of an

award, or during a graduation ceremony, use a long lens to capture the trophy or diploma changing hands. Do not be satisfied with simply recording the entire stage as the child you are interested in takes his or her turn in the proceedings.

Before and After the Ceremony. When the ceremony is over, make records of the pride on the faces of the participants and their parents; of the look of relief on the faces of kids who can now go back to less restricted behavior, and so on. If you are an intimate of the people involved in the ceremony, you might try to record their preparations for it. These photographs, along with those made during and right after the actual event, will be a welcome addition to your friends' family album. If your own kids are involved in the ceremony, you might want to photograph their preparation, if you have time—but leave the rest of the picturemaking to some other competent individual, so that you can enjoy the event first-hand, not through the eyepiece of your camera.

With any ceremony there is usually one instant in time that captures the essence of the event. Before the event takes place you must know the picture you want, anticipate the action, and find a position with a clear view of the scene.

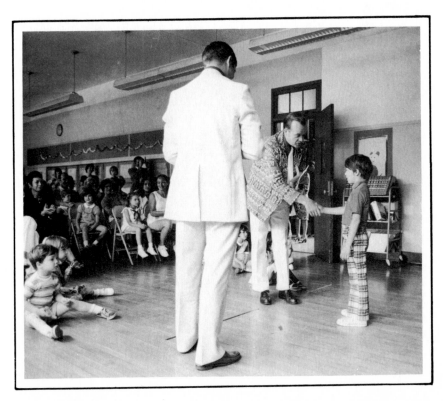

4

Portraits of Children

Of all the pictures made each day of people, only a small percentage can be considered true portraiture. And, of all these true portraits, only a small percentage is of children, even though more than half of all "people pictures" are of kids. How so? Well, most pictures with youngsters as their main subjects are more about childhood than about individual children. The pictures show some aspect of growing, or of play, or of participation in some public or family event. Such pictures work well no matter who their youthful subjects are.

Real portraits, however, work because their subjects are irreplaceable. The pictures go beyond the physical appearance of the subjects and show the personalities hiding beneath. The viewer should be able to walk away from a good portrait with a clear impression of the subject's true self, clearer even than one he or she might get from meeting the subject for the first time.

This may be easy or difficult to do, depending on your experience as a photographer and your ability to interact with children. Whether or not you have had success making portraits of adult sitters is irrelevant. The moment a child sits before your camera, a new set of rules applies. The key to success in child portraiture lies first and foremost in your feelings about children, and your understanding of the way they respond to you. If you genuinely like children and are comfortable around them you will more often than not be able to gain their trust and go on to make good portraits.

For a picture to be successful the subject does not have to be scrubbed and neat. Griminess is a natural state of childhood, so why not picture a youngster that way?

The way you approach your portrait sessions will depend on three factors: how you envision the finished portrait, i.e., whether you want a formal or informal look; the age of your subject; and how well you know the child before the shooting. The formality or casualness of the picture depends on your own style as a photographer and on the last of the three conditions: It will make little sense to take an unknown ten-year-old into the studio, set up lights and a view camera, only to discover that you and your sitter do not get along, and that you have nothing to say, photographically speaking. At best, such a situation will produce a very sharply rendered, professionally lit picture of a bored, resentful, or uncomfortable child; at its worst, your picture will be of a child who wears a vapid, artificial smile. To prove this to your-

Reflected or "bounce" electronic flash is a good lighting source for capturing adolescent horseplay in mid-tickle without glare or harsh shadows.

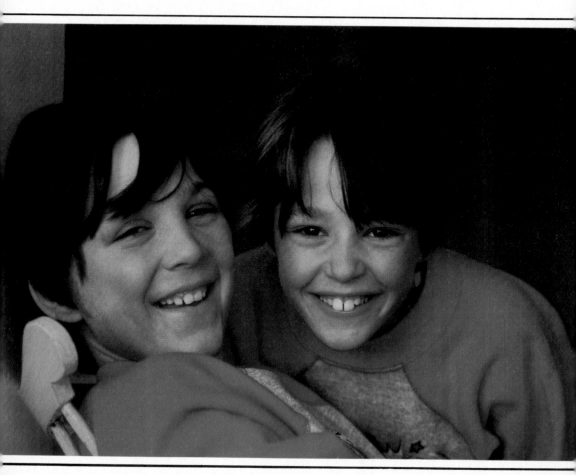

Informal portraits can be make almost anywhere at anytime. Here the child was photographed in the doorway of his house while waiting for a friend. Though the setting and mood is informal, the picture was carefully taken.

self, look through the catalog of any commercial child portrait studio —the majority of the pictures will do little more than describe the physical characteristics of the subjects. These are not portraits.

We are not suggesting that you should attempt formal portraits only of kids you know intimately; on the contrary, you may feel comfortable with a youngster you've just met whose demeanor cries out for a formal portrait. But even then, the good rapport is not enough; you will be guaranteed of success only if you have a clear idea of the finished picture *before* you ever press the shutter-release button.

Formal portraits of very small children are easy to make. If your subject is barely of talking age, you can occupy him or her with a toy or attract the subject's attention by waving your hands while you wait for the expression or body position you feel best shows the child's personality. Making formal portraits of teenagers should also be reasonably straightforward; to put them at ease, you can use techniques of conversation you've used with adults, since by this time, your teenage subjects have had experience communicating on a mature level.

At all age levels, informal and/or environmental portraiture is the easiest and usually most gratifying form of portraiture for you and for your subject. For one thing, you will need little or no preparation for an informal portrait. The right moment might come along at any time —indoors or out—all you need do is recognize it and react in time. Whenever a child is in familiar surroundings—in his or her tree house or room, or at play with friends—the potential for making environmental portraits is high.

A special glow of excitement appears on the face of a child engaged in a favorite activity. It pays to get in the habit of bringing your camera to the action rather than waiting for it to come to you.

Making Informal Portraits Outdoors

Every time a child catches your photographic attention, you have several choices: You can concentrate on what the child is doing; on how the child looks; on what makes him or her "special" and unique; or on what the small person in front of your camera means to you. If you combine all of these considerations into one extremely attentive appraisal of your subject, you are in the process of making a portrait. If all of this happens outside the confines of a studio, you are making an informal portrait. In this text a "candid" portrait refers to a portrait made on the spur of the moment, without the sitter's awareness that the picture is being made. In general, however, the terms "candid" and "informal" are interchangeable.

Environmental Portraits. There are two main types of informal portrait: those that show the subject as the only part of the photograph; and those that include some area or object that is meaningful to your sitter which helps the viewer understand your subject better. The latter type is generally referred to as an "environmental" portrait; in the case of adult sitters, an environmental portrait might include the subject's workplace, a piece of art or craftwork the subject has made; or a section of your sitter's living quarters. In your environmental portraits of children, you might want to include a favorite playing area, a secret hideaway, or some pursuit the child is good at such as playing a musical instrument. In any event, make sure that the area or item you include does not overpower the person in the picture; let it aid, rather than control, the feeling your portrait conveys.

Don't think of a portrait only in terms of facial expression. Train yourself to look at the whole child; stance and gesture can be quietly expressive.

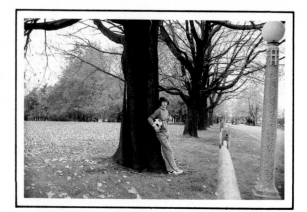

These four photographs were all made at the same subject-to-camera distance. In this picture, a 35mm moderate wide angle lens shows the subject relatively small in the frame and well separated from the background trees.

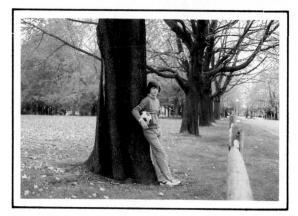

A 50mm lens is "normal" for 35mm photography. It reproduces scenes most nearly the way the human eye sees. Here you see the boy and the trees in about the same perspective as the photographer did at the scene.

Lenses. If you are sufficiently in tune with the children around you, you can find good informal portrait subjects in any playground or park. Walk around with an 85 or 100mm lens on your 35mm SLR (single-lens reflex); or better yet, use an 80–200mm zoom lens for candid portraits made from a greater distance. If you do not feel the need for the extensive reach a 200mm focal-length lens gives you, try a 70–150mm zoom. Many of these are less expensive, smaller, and at least as sharp as the 80–200mm variety, while offering almost as much "reach."

Your candid portraits will be more successful if you observe your prospective subject for some time before you decide to make the exposure. With a long lens in place, or with your zoom at its longest focal length, you can stay out of sight of the youngster as you observe. When the child is not looking your way, raise the camera and focus, making correct exposure settings as you do so. Allow enough depth of field to get the head and eyes sharp by closing down the lens one or two stops —depth of field with long lenses at their maximum apertures is very shallow, and if you are not careful, you might render the child's ear

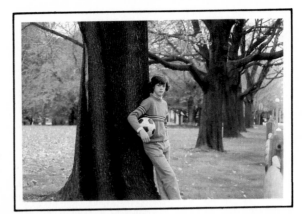

A somewhat longer than normal lens (70mm here) is the most common choice for portraiture. Notice that the background becomes more prominent as the focal length of the lens increases.

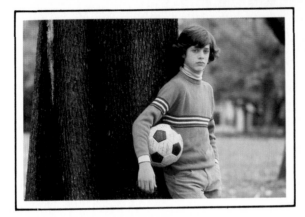

With a 135mm lens the boy is larger in the frame than with shorter focal-length lenses and the background appears to be much closer to the subject.

sharp, leaving the rest of the face out of focus. Keep the camera in your lap, and observe your subject until he or she shows a characteristic expression—a tilt of the head, a raised eyebrow, or whatever it is that makes the personality come out—then quickly raise the camera and make your exposure.

Establishing Rapport. For more direct informal portraits of children with whom you are not familiar, be friendly and open. Talk to their parents first, ask their permission to make your pictures; then engage the child in conversation, keeping your camera handy. Before you raise it, though, let the camera become a familiar part of the child's surroundings. Avoid the "grabshot" method of getting your picture if you are talking to the child; your sudden movement might destroy any trust you may have built up. Ask the child if you can make the picture. In order to break the ice, and if the child looks capable, you might ask him or her to make a picture of you.

If you are making portraits of a child who knows and likes you, your task will be that much simpler. Give the child something to do,

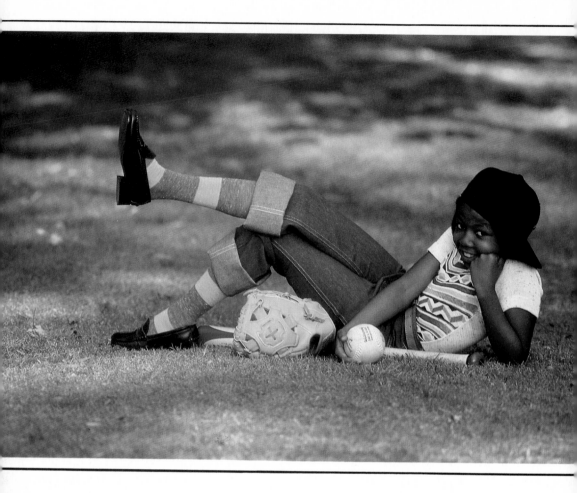

Try to photograph children at their own eye level, even if it means getting right down on the ground with them. Otherwise, distortions will result.

or wait for a moment when the youngster is involved in something and not paying too much attention to you. Pets help in this regard—you are far more likely to be ignored by the child if there is an animal to play with.

Unless you are very short, avoid shooting your portraits from your eye level—rather, place your camera at the child's eye level; otherwise, you will end up with an unpleasant distortion, such as the subject's head photographing larger than it ought to.

Film. There is no perfect film for portraiture; if you want extremely well defined features, use a slow, high-resolution film, but be aware that you will be limited to slower shutter speeds and wider lens openings in anything other than bright sunlight. If you make your

portraits with a fast lens (100mm at $f/2$ or 85mm at $f/1.8$, or so) and your subject is not particularly active, you should have no problem; but to give yourself more flexibility, especially if you are making candid portraits of unknown children, use a faster film. The loss in image quality will be more than made up for by your increased mobility.

The zoom lenses mentioned earlier usually have apertures starting at $f/3.5$ or so; with these lenses, you will need fast films unless you are shooting in brilliant sunlight. Even though the light may be reasonably bright, you will need the fast shutter speeds they allow to ensure sharpness while handholding these lenses. You should not attempt to handhold a lens at shutter speeds slower than 1/the focal length of the lens (use a 100mm lens handheld at 1/100 sec., no slower, and so on); apply this rule to the longest length of your zoom lenses.

Low light levels require fast films and fast lenses set at wide apertures to produce correctly exposed photographs. When using wide apertures, remember to focus very carefully on the most important part of your subject, as depth of field is quite limited. Photo: W. Updike.

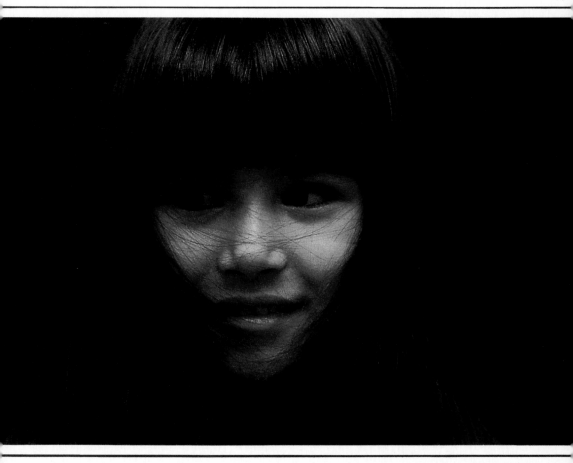

Available Light Portraits Indoors

For effective portraits in artificial light, whether roomlight or tungsten bulbs, you will need to find a location that is photographically pleasing and comfortable for your sitter. Do a little housekeeping, removing from the scene any distracting bric-a-brac, newspapers, or magazines. People looking at your portrait should be able to focus on the subject, not be drawn to bright colored objects in the background or foreground. Also remove anything that might look anomalous in a child portrait. A full ashtray is not only an unpleasant sight, but it is also ridiculous; unless, of course, your young subject is a chainsmoker.

In general, you will find that the best spots to create the pictures you are after are in surroundings familiar to the child. The play area in his or her home or the children's room are ideal locations for informal portraiture.

As much as possible, make all of your light readings, lamp adjustments, and other arrangements before you begin to shoot. In this way, you can spend your time holding the youngster's attention and interest, rather than losing it as you fuss with your equipment.

Lighting and Exposure. If there is a conveniently located window, you might try making your more conventional portraits using its

A well-lighted bathroom can become an impromptu "studio" for informal portraits like this one. A long lens was used at wide aperture, to throw the background out of focus. The result is that all of the attention is drawn to the subject's expression.

Tungsten light bounced into a large reflecting umbrella provided the soft illumination evident in this portrait. As in the photo opposite, a long lens and wide aperture were combined to get rid of the distracting background details. Photo: T. McGuire.

light as the main source of illumination. For best results, place the child on the windowsill or in a chair near the window, so that the diffused sunlight coming through it illuminates the sitter's face and shoulders. To fill in the dark areas of your subject's face, use a large white card, or a sheet, from the shadow side as a reflector. You can control the lighting arrangement by bringing the reflector closer, or

Window light, especially on slightly overcast days, produces an excellent source of illumination for indoor portraits. Use a large white card or piece of white cloth to "fill in" the shadow side of your subject. Photo: H. Weber.

moving it further away. Pay attention to the difference in tone between the shadow and highlight side of the face; whatever you see with your eyes will be magnified on film.

Generally speaking, the lighting will look most natural if there is no more than a two- or three-stop difference in tone between the shadow and highlight sides of your sitter's face; a one-stop difference might appear too flat and even in black-and-white; and a greater than three-stop difference will look dramatic and diminish the details in darker portions of the scene, especially if you are using color films.

Use an exposure meter, either built-in to your camera or handheld, to make a closeup reading of the light side of your subject's face; then do the same on the shadow side. Move the reflector back and forth until the shadow side of the face reads two stops less than the highlight side. If you are shooting in black-and-white or with a color negative film, place your exposure settings in between the readings you get; or, for a lighter feel to your portrait, base your exposure on the shadow side of the face. If you are shooting with color transparency films, make your exposure based on the bright side of the face.

For an ethereal, airy portrait, have the child sit with his or her back to the window, and place your reflector directly in front of and a little below your camera. Make a closeup reading of your subject's face, ignoring the backlight from the window itself. If you are using an

You will find it relatively easy to make informal portraits while the child is involved in some characteristic activity. In this picture, the windowlight provided the sole illumination; the light colored walls of the room acted as reflectors, giving adequate illumination of the shadow areas. Photo: T. McGuire

automatic exposure camera, depress the backlight switch, or increase the automatic exposure by 1½ or 2 stops with the exposure compensation control. Make sure that you have the proper lenshood attached; this will lessen the flare that occurs in backlit situations. If there is annoying background detail on the outside of the window, use a wide lens opening to throw the background out of focus. If you have the time and energy, hang a smooth, white, translucent piece of cloth on the outside of the window to get rid of unwanted background detail and to further diffuse the light.

Lighting. If you need extra illumination, or are shooting with tungsten-balanced transparency film, you might try putting tungsten bulbs in the lighting fixtures. You may find that moving the room's lamps will provide better illumination. If you do move room lamps around, make sure you put them in appropriate places; or frame your picture in such a way that the lamps illuminate the sitter but do not appear in the shot. Be careful not to cross-illuminate your subject— light coming from opposite directions rarely looks right and might cause ghastly shadows on your subject's face. Try to get the lighting broad enough so that even if your subject moves around a little—and children do fidget—his or her main features still remain well lit.

Film. If you shoot with color negative film or in black-and-white, you need not be overly concerned with lighting. For color, use ISO/ASA 400 film; for black-and-white, use any fast film. If you want good image

For quick work in a variety of lighting situations use ISO/ASA 400 films. These will allow you to get sharp, hand-held images under all but the dimmest conditions. Photo: N. De Gregory.

Fast lenses of 85mm or so in focal length are ideal for 35mm available light portraiture. They will allow you a comfortable working distance, and will help you avoid the facial distortion that might occur should you try to make closeup portraits with a normal lens. Photo: N. De Gregory.

quality, avoid "pushing" your film. No matter what the advertisements imply, you cannot effectively increase the true speed of your film beyond the ISO/ASA speed printed on the package. When you rate the film at a higher speed than the manufacturer suggests, you are in effect underexposing your picture and developing longer to compensate for the underexposure. This diminishes detail and tonal separation in the dark areas of your picture and might cause overly dense light areas with no definition in them.

For really low light conditions, use one of the new chromogenic black-and-white films. These specially designed films are more expensive and require the same kind of processing as color negative films; their benefit is that you can use them at any speed from ISO/ASA 125 to ISO/ASA 1600 with no appreciable loss in image quality. You can change the speed rating of the film in mid-roll and still end up with well-exposed negatives. The slower you rate this kind of film, the less grain you will see. Best overall quality is usually gotten at ISO/ASA 400 or thereabouts, but you can use the 1600 rating for good results with slightly more obvious grain.

Lenses. The best lens for available light portraiture with a 35mm SLR, is a slightly long focal-length lens—85mm or thereabouts. Most of these "portrait length" lenses have maximum apertures of $f/2$ or better, allowing you to throw the background out of focus so that nothing detracts from your subject. The large maximum aperture will enable you to handhold the camera, but if necessary, have a small but sturdy tripod at your disposal.

Formal Portraits of Children

Formal portraiture has some definite advantages over the less structured types. For one thing, you have complete control over the lighting in a formal situation, so there is no need to compromise with the surroundings. For another, the camera and sitter's areas are permanently set—you can be ready for a session far in advance. In addition, the large cameras used in portrait studios offer increased fidelity; until you have seen a well made 8″ × 10″ negative or transparency, you have no idea of the kind of quality to be gotten out of the photographic medium.

Clothing and Props. Because of the lack of background in formal portraits, the physical attributes of your subject become all the more important. The clothing he or she wears is important; so is anything that might be held in the hands. One major failing of most commercial portraits of children is that the subjects usually hold toys that are either inappropriate or non-descriptive of the child's personality. Toys may capture the interest of a child, but in many cases, they look out of place in the photograph. Since formal portraits become historical records, both of the subject at that age and of your perception of the

Formal portraits are most successful when they show clearly the subject's characteristic expressions or gestures. Backgrounds and props should usually be kept as simple as possible. Here, the white chair melts into the background, taking no attention away from the young girl's intent gaze and carefully placed hands. Photo: D.E. Cox.

You do not need a large format camera to make successful formal portraits. A 35mm SLR loaded with fine grain film was used to capture this girl's bright expression. Photo: J. Powell.

child's personality, you should take care to ensure that every square millimeter of the photograph says something meaningful about the subject; if not, it should remain completely neutral, acting as a frame for the personality your portrait holds.

Cameras and Film If you have a child with especially fine features, beautiful eyes or hair, and so on, you might like to try your hand at a formal portrait. You will not necessarily need a view camera; formal portraits can be and are made with rollfilm and 35mm equipment. If you are going to use a small format camera, get the highest resolving, finest-grained film you can find.

For black-and-white portraits, use slow-speed films—ISO/ASA 32 or 50. If you are going to make your formal portrait in color, use electronic flash and a good daylight-balanced color transparency film. Failing that, use tungsten lighting and the slowest, finest-grained, tungsten-balanced transparency film you can find.

Other Equipment. Besides your camera and film, you will need a sturdy tripod; a cable release; at least two lights (one for the main illumination, the other placed some distance beyond the main light to act as a fill light) with some diffusion material to soften their output; a large reflector panel or white sheet; and a neutral background. A

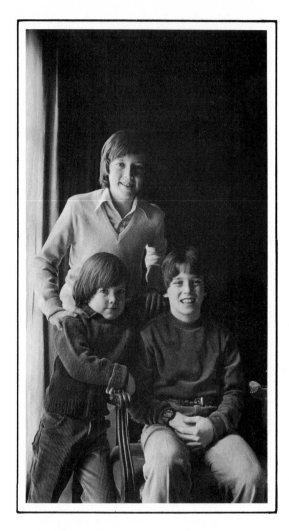

*Spend a little
time getting to know your
subjects before you begin
to photograph them, Let them
get used to being in front of
the camera, and you will find it
easier to avoid self consciously
posed, stiff looking portraits.*

piece of smooth canvas or some photographer's seamless paper is ideal; for a more old-world look, you might use a dark curtain or a large piece of velvet.

As with other types of portraits, use a slightly long lens (85–100mm for 35mm cameras) to lessen the chances of distorting your sitter's features. The long lens will also allow you to work at a comfortable distance from your subject.

Putting Your Subject at Ease. You will undoubtedly have some trouble with a frightened child. While some young subjects enjoy the attention they are getting in the studio and are quite cooperative, others become frightened by the strange gear, the unfamiliar surroundings, and their lack of control over the environment. These children will have to be pacified in some way in order for you to make

effective portraits. At these times you would be advised to divert your subject's attention from his or her fear. This can be done in stages. First, disassociate yourself from your camera gear; show the child that you are harmless. Then give him or her a toy or some object to play with. When the child is engrossed, you can begin taking photographs. Once the subject is used to the camera, you can try taking the toy away and giving the subject a more characteristic object to hold. You might also try giving the child posing suggestions.

In most formal portraits, the subject looks directly at the viewer. This pose is simple to obtain from adults, but you cannot always count on the same kind of cooperation from children. You will have to convince them to look where you want them to.

Formal portraits need not always be tack-sharp renditions of the subject. Here, the photographer used a diffusion filter on his lens to soften the girl's features. Photo: R. Farber.

Directing Your Model—Small Children

In general, small children are not particularly self-conscious around cameras, as long as they are left alone to do what they want. In a portrait sitting, it may be more difficult for them to relax than it would be if you were just photographing them as they played. If you can, avoid making them feel as though they are being manipulated into posing for you. Gain their interest with something unrelated to the portrait sitting. If the child is of the age when stories are interesting to him or her, tell one enthusiastically while you stay near your camera. Keep your eyes in line with the camera lens, and wait for reactions to your story. Make your exposures via a cable release, and continue telling your tale as you prepare your camera for the next exposure.

If you are making your portraits in a studio, be sure to have items on hand that the children you photograph can play with. Unless you want your portraits to look like advertisements for the local toy shop, however, avoid games and toys that have name brands on them, or that will quickly go out of date. Most small children are extremely clever at improvising their own toys and games from the most unlikely objects. A couple of empty thread spools with a knotted piece of string through them or the discarded backing paper from a roll of 120-size film will hold the interest of many kids just as well as a popular toy will. The smaller the item, the better; you will be able to make your pictures

Technique Tip: Magic in the Studio

If you are using a view camera, and the child is interested in it, offer up a piece of simple magic: Suggest that you can turn everything upside down through the "magic window" at the back of the machine. Have the child's parent or an accomplice sit in the subject's position, then bring the child to the ground glass and show him or her how the world appears topsy turvy when viewed through it. Having done this, ask the child to sit in the subject position and look into the small round window (the front element of your lens) to see what he or she can see. Tell the child that sitting still "helps to see what happens." Hopefully, the child will be intrigued by the sound of the shutter, and will remain in place to try to see what makes the noise and what that strange little movement in the lens is as the shutter opens and closes. Thus, you will be guaranteed of at least one steady exposure. This is just one of the many games you can use to make the session fun for the child; other games may become obvious as you get to know your subject.

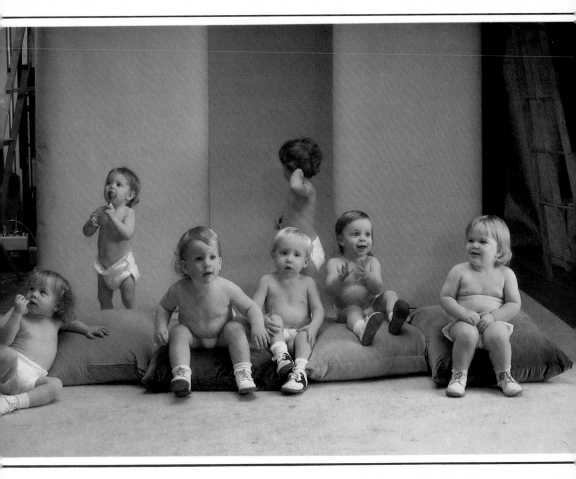

Getting a good picture with this many toddling subjects can be quite a problem. Ease the problem with careful preparation, patience, and (in this case) a large supply of extra diapers.

without including the plaything. Electronic games that emit musical notes are a godsend to child portraitists—the musical tones will keep a child's interest for a long period of time.

Such items as rattles and hand puppets will hold very small children's attention if you operate your camera with one hand while manipulating the toy with the other. If you are adept enough, a simple sleight of hand trick of the "now-you-see-it-now-you-don't" variety will keep a small child delighted for minutes on end. There are as many ways to get children to cooperate in front of the camera as there are children—your job is to quickly find the way that works best with each of your subjects.

The worst thing you can do is to make the portrait session seem important and "grownup." Make the entire event an adventure or a game, and cooperation will be assured.

Teenagers are at a very touchy period in their lives; some handle the emotional changes they are going through with aplomb, others do not. In any event, the teenage years are usually the most self-conscious ones; getting a nervous teenager to relax in front of a camera takes a little patience. In general, the more you reveal of yourself, the more inclined your nervous subjects will be to reveal themselves.

Do not begin the portrait session by asking your sitter to relax, or admonishing him or her not to be "uptight," or whatever the vernacular happens to be at the moment. Neither should you attempt to put on a fake show of enthusiasm; instead, act calm and proficient. Get to know the person you are about to photograph; discuss things of mutual interest. Act friendly and interested without patronizing. Do your research properly: Find out if your subject has a job; what school interests he or she has; what sports are played, and so on. As you discuss these things, set up your equipment, make light measurements, load your cameras (if you have not already done so), and so on, without drawing attention to any of these things. The more you appear to do your job smoothly and confidently before you begin to make exposures, the better your chances are of building your subject's confidence in you, and the more relaxed and natural he or she will be when the shooting starts. Keep in mind that your teenage sitter believes that the session begins the minute he or she arrives, whereas for you, it begins when you make your first exposure. In view of this, if you make all the preparations you can before the sitter arrives, the portrait will happen quicker. This way you can spend the initial moments devoting all of your energies to communicating with your subject.

Some teenagers like to participate directly with the things they find themselves involved in. If you detect an interest in the photographic proceedings, get your subject involved by having him or her hold the exposure meter for you or by having your sitter perform some other small chore. If the interest is in the shooting end, offer to pose for your model; if your subject has any photographic experience, do not offer advice unless you are asked for it. If not, help wherever possible. Once they have had a chance to turn the camera on you, most children and teens will be more relaxed on the other side.

While all of this is going on, keep the conversation alive, but unforced. Long lulls in the conversation that occur because you are concentrating on focusing or the like might degenerate into uncomfortable silences, so be aware that keeping your sitter's interest is more important than anything else you might be trying to do at the moment. As much as possible, keep your eyes where your sitter can see them. Do not disappear behind the lens or the ground glass for more than a second at a time; and when you do, keep talking; otherwise your sitter might think that you are not paying attention.

Sometimes getting away from distractions will help a teenage subject relax. Go wherever you like, but make sure you and your subject are alone when you pick up the camera.

A compact flash unit effectively acts as a point source of light and produces bright, specular highlights (note the black piano keys) which can add life to a picture.

Flash and Floods for Child Portraits

The fundamental lighting techniques for artificial light portraits of children are the same as those for adults. The only additional consideration is that some children might become a little skittish in an area with an elaborate lighting setup. There is also the added problem, with active youngsters at home, of having to keep track of them as you set up and break down the lights. Keeping them out of the room while you do this will prevent burns on hot bulbs or trips over exposed wires.

As mentioned before, you can substitute tungsten bulbs for incandescent ones in your living room lamps. However, tungsten bulbs are generally used in their own stands; they are available with various size reflectors and other attachments to help you control the direction and character of the light they produce.

Tungsten and Quartz Lamps. Tungsten and quartz lamps are available in a variety of intensities. The most common are 250, 500 and 1000W bulbs, all of which have standard, threaded connectors. Using the 500 and 1000W bulbs in standard household fixtures is dangerous because of the power and heat these bulbs give off. If you need this much light, or if you are interested in setting up a small studio, invest in lamp housings made especially for photographic use. These are stur-

dier, far more flexible and better ventilated than regular household fixtures. They are also equipped with connector sockets for light stands, which you should also obtain. Several light stands collapse into small, tripod-like shapes for storage, and expand to heights of almost 2m (6 ft.) for use.

Electronic Flash. Studio size electronic flash equipment is relatively expensive. A complete outfit of two flash heads, a power source, and the proper connectors, cables, and so on could easily cost you twice as much as you spent on all of your cameras and lenses. Professional photographers who do fashion and illustration assignments on a daily basis need the power and versatility this kind of electronic flash lighting offers. If your interest is solely in making portraits of children, you do not need such power.

If you like to work with electronic flash, there is a far less expensive way to meet your lighting requirements: Buy a small but powerful "potato masher" style flash unit, of the type used by press photographers and photojournalists. Many of these units give automatically controlled flash output that guarantees you correct exposure under all sorts of lighting conditions. For additional flash lighting, buy a smaller, on-camera flash unit—you may own one already—and a "slave sensor" that will automatically fire the second unit when the main one goes off. Some companies make slave flash units that have the sensor built in. These are expressly designed for use as fill-in-flash to add extra light in shadowed areas.

A nice feature of electronic flash is its complete portability. When trick-or-treaters come to the front door there's no time to set up lights. With a compact flash unit on the camera you'll be ready immediately. Photo: F. Leinwand.

Lighting Arrangements. Whether the source is flash or flood, portrait lighting is arranged the same way. There are no set rules for positioning the lights, save one: In most cases, your portrait will be most convincing if the lighting is not too obvious. Usually, all of the light in your portraits ought to look as though it were coming from one direction. To achieve this, begin by establishing the position of your main light. You will find it easier to work with continuous light sources at first, since you will have to wait until the film is processed to see what electronic flash looks like in your pictures. (If you do not own photographic lighting, practice with incandescent, household lamps.)

In all probability you will find that the most even lighting will occur with the lamp nearest the camera, pointed almost directly at your subject. While even, this light is also a bit boring. It flattens facial features and leaves unpleasant shadows under the chin. With the lamp placed at the side of your subject, you will get a "half moon" effect—one side of the face will almost be in complete darkness, while the other side will be strongly lit, showing all of the texture in your sitter's face. At about 30° to your sitter, there will be good modeling of the facial

Technique Tip: Setting Up The Lights

Get a volunteer to sit in front of your camera as you experiment with the lights. If you are using household bulbs for your lighting experiments, get a few aluminum light reflectors for plants from the hardware store, and buy a pair of photographic light stands (you will need these no matter what kind of lighting you decide to buy). Use 150 W or brighter incandescents for your experiments; if you have no such bulbs in the house, use the most powerful ones you do have. Attach the bulbs and reflectors to your light stands with alligator clamps.

Place your volunteer in front of the camera, put one of the lamps on one side of your subject, and turn it on. Turn off all other lights in the room. With the test lamp on, examine the shadows cast on the wall behind your subject. Move the lamp up and down on the stand, and observe the shadow. You will see that as the lamp is lowered, the shadow behind your subject rises, and vice versa. Now turn the lamp a little to the left, then to the right. You will find that the shadow moves in the opposite direction. Move the lamp up and down, back and forth, and sideways until you get a pleasing cast of light on your helper's face. If your subject moves his or her head, you will also notice changes in the shadow. Make mental notes of all these things; or better still make pictures of each light setting so that you have a permanent record.

a

b

c

d

These diagrams show the relationship between the subject, camera, and main light for four basic lighting arrangements. Fill lights and others would normally be added to soften the effect of the main light. (a) butterfly or glamour lighting; (b) 45° or Rembrandt lighting; (c) hatchet or side lighting;(d) rim or back lighting.

If the light source cannot be moved, emphasize the most interesting aspects of your subject by placing him or her so that the light falls where it is most effective. Here, the boy was positioned so that most of the light fell directly on his face and shirt.

features, but dark shadows on one side of the nose and cheek. At this point the second light should be used. By placing the second light, or "fill" light, on the shadow side of your subject, you can fill in the dark areas as much or as little as you want simply by moving it back and forth.

The idea of main (key) and secondary (fill) lights is what all lighting schemes, no matter how ornate, are based on. If you have two lights of equal intensity but want the fill light to be half as strong as the key light, move it a bit more than twice as far from your subject as the key light; or use a bulb with half the wattage, and keep it at more or less the same distance. The reflector card you used in natural light settings will serve the same purpose as the fill light, only with less effectiveness at greater distances.

Lighting Ratios. You will also notice as you play with the lights that the illumination can be a bit harsh, giving you shadows with clearly defined edges. To soften these up, use diffusing material on the front of the reflectors. Various types of diffusing materials are available from any well-stocked camera store.

Diffused or not, do not go beyond a two-stop difference between the illumination on the right and left sides of the face. To establish a pleasing ratio, turn on the lamps, arrange them until the effect produced on your subject's face is the one you want, then turn off the fill light, leaving the key light on. Have your subject hold a white card in front of his or her face, and with the key light on, make an exposure reading of the card. Make a note of the reading; turn off the key, turn on the fill, and make another reading. Compare both readings. If they are about two stops apart, you will get good results. If not, leave the key light in place and move the fill light until you get two stops difference in readings.

For more even lighting, move the lamps around until the difference is less than two stops. For a more theatrical effect, make the difference three stops; but keep in mind that what you see will be exaggerated on film, especially if you shoot in color.

Keep notes on every lighting change you make. Make photographs of the results, if possible. Having spent a few days practicing lighting, you will find it easier to prepare for portraitmaking.

Lighting ratios with electronic flash are easy to establish but difficult to see, unless you have an instant camera handy. Another way to determine flash exposures and ratios is with a flash meter—a specially designed, handheld exposure meter that is sensitive to the extremely short burst of illumination flash units give off. Using a flash meter will allow you to read key and fill lights in the same way you would read tungsten lamps with an exposure meter. You can predict the approximate effect of the flash light by setting up tungsten or incandescent bulbs in small reflectors at the electronic flash light positions. Determine the lighting with the incandescents to your satisfaction, then put the flash lamps in their place for the actual shootings.

5

Special Considerations

Besides the normal problems of lighting, getting and keeping a child's attention, selecting the appropriate setting for photographs of children, and so on, there are a few out of the ordinary situations to consider. These include the best way to get rid of reflections in a child's eyeglasses or braces; what to do with a teenager who has a temporary skin flareup; how best to handle photographing a family get-together when you are an outsider; and who to emphasize when photographing a child with an adult and who is in charge of the shooting—you as the photographer, or the adult in charge of the child. All of these situations are bound to arise at one time or another as you go about photographing kids.

There is a solution to all of these frustrations. Eyeglass reflections, braces, and problem complexions can all be made less bothersome by changing the lighting, repositioning your subject, or adding various lens or light attachments. A little common sense and diplomacy will help you get pictures of private family gatherings without your becoming intrusive. If you have been invited to make pictures at a family affair, you can seek your host's aid in organizing the guests for picture taking. Or, if you have quiet camera equipment and can work fast, you might be able to get pictures of kids and family without even being noticed.

A special bonus of family parties is that you can take advantage of the opportunity to document a child's relationship with his or her parents and other family members. If the gathering is formal, such as a wedding party, you will have the chance to make pictures of what the kids do while the grownups play.

To give a picture visual unity, pose subjects so that their faces (the center of interest) are in the same area. Ask tall people to kneel or sit down and have them give a boost to young children.

Eyeglasses, Braces, and How to Cope With Them

Under most lighting conditions, making pictures of people wearing eyeglasses can be a problem, unless you are very careful about where you stand with your camera; what kinds of things are in front of and behind your subject; and where the light is coming from. Even if the subject is not looking directly at you, your camera position may be such that you will record unwanted reflections in the spectacles, or get bright, unmanageable glints from the metal rims. If the sun is behind you, it might reflect from your subject's glasses directly into your lens, causing untold amounts of flare. If you use an SLR camera, you will see this reflection and be able to avoid it; if you are using a twin-lens-reflex or rangefinder camera, however, the viewfinder or viewing lens might be off just enough for you to be unaware of the problem until you see the photographic results.

Eyeglasses. Often, you can eliminate reflections from eyeglasses simply by changing your shooting angle. If you stay about 30° to the side of your subject, you should be able to keep out of the reflective path of the eyeglasses. If you are photographing a cooperative youngster, you might ask him or her to move until the reflection disappears.

In more severe cases, where there are distracting elements reflecting in the eyeglasses no matter where you stand or which way your subject moves his or her head, there are three practical solutions: You can move to an entirely different location (across the street or under the shade of a nearby tree might be "different" enough); you can suggest that your subject remove the glasses; or you can use a polarizing filter—a specially designed, double-walled filter used to cut reflections.

In diffuse light, such as that in the picture at left, reflections are rarely bothersome. Photo: B. Barnes.

Reflections in eyeglasses can be eliminated by using a polarizing filter or by diffusing the light falling on a subject. Photo: H. Weber.

Sometimes it is very difficult to eliminate reflections in eyeglasses entirely. If it proves difficult or impossible your only choice is to try to place them where they do not detract too much. Photo: B. Anish

Polarizing filters are easiest to use with SLR cameras because you can easily see their effect. However, polarizing filters will not cut reflections from metallic sources. If your subject is wearing metal-rimmed glasses, you must change your viewing angle or your subject's head position until the frame reflection is gone, then you can use the polarizing filter to get rid of any reflections in the glass.

Braces. Dental braces are usually made of metal and are therefore hard to control with a polarizing filter. Fortunately, their reflective surfaces are small and easily brought under control by slight changes

Technique Tip: Eliminating Eyeglass Reflections

If you are making studio portraits and have problems with eyeglass reflections, change your lighting and/or the position of your subject. To get rid of your own reflection in the glasses, you will need a prop. Cut a hole in the middle of a large black card. Then position the card between your camera and your subject, using the hole for the camera lens to peek through. If your sitter is young enough, you might conjure up a game of peek-a-boo as you bob up and down between exposures.

in the position of your lights. Some teenagers are rather embarrassed by their braces, and have a tendency to keep their mouths closed in a self-conscious way. With a little extra patience, you can usually relax these youngsters enough so they will assume a more natural expression. Other teens have no qualms about flashing a metallic smile. If they do not mind, and have agreed to pose for you, why should you mind? Make pictures with the braces showing, and one or two with the mouth closed. When the photographs are made, both you and your subject will be able to pick out the most representative exposures.

You might help a teenager overcome a feeling of self-conciousness by giving your subject something to do and someone to relate to while posing. In addition, bright reflections from braces can be eliminated by using a diffuse light source. Photo: N. deGregory

Overcast daylight is a good diffuse light source for portraits at all ages.

Teenage Complexions

Along with a host of other minor traumas, teenage years bring with them the problem of unpredictable skin flareups. Pimples, acne, and various other dermatological disasters occur at the most inopportune times, and are sometimes brought on by stress. If you find yourself having to photograph a distressed teenager with a skin problem, there are a number of things you can do to make the blemishes less obvious.

Lighting. First, stay away from direct lighting, especially side-light. These will accentuate skin texture and make the blemishes stand out. Use spun glass, translucent plastic, or other diffusing material over your lights, or bounce the light into a white photographic umbrella for a softer effect.

Filtration. Once the lighting has been adjusted, the blemishes should be less apparent. If you need to further reduce the texture of the face, place a soft-focus filter over your lens or attach a skylight filter smeared lightly with petroleum jelly. To maintain some sharpness in the photograph, remove the petroleum jelly from the center of the filter using a cotton swab.

Printing Papers. If the sitter wants black-and-white prints, make them on a non-glossy surface, preferably with a slight texture. The surface of the paper will help make the blemishes less obvious. Diffusion material such as nylon mesh or cellophane can be used during the enlargement exposure to soften the texture of the face as well. A combination of any or all of these methods ought to hide any ordinary complexion difficulty.

Retouching. As a last resort, you might take the exposures to a commercial retoucher. This is expensive but is guaranteed to succeed. A good retoucher is worth his weight in uranium to commercial photographers and portraitists—he or she can make people look fatter or thinner; can remove or replace backgrounds or even people in photographs; and can combine a number of photographs into one without leaving a trace that they were ever separate images. To a person with this kind of skill, removing a blemish is child's play, but expensive child's play.

Choosing the Right Angle. In many cases, the simplest solution to the complexion problem might be the best: Hide it beneath a strategically placed hand or finger; reposition your sitter; or take profile photographs. Skin irritations rarely affect the entire face equally.

Even if you use these methods, you may want to make plans for a second shooting at a time when your subject's skin is in better shape. If your photographs work the first time, you can always cancel the second sitting; if not, you will be prepared for a new session.

Children with Adults

Photographing children as they deal with their elders can be a rewarding pursuit. Often, you will find that you can make stronger pictures with just part of the parent or other grownup in the frame; a large hand being held by a toddler will say more than a full figure shot of the adult with the child at his side. Photographic opportunities of this sort are everywhere, especially on weekends when the parents are out for walks with their kids.

Take a stroll through your local park or shopping mall on a Saturday afternoon, and look for children with their parents. When you find a likely looking family, observe them. Does the child veer towards his or her mother or father? Which of the parents seems to be responsible for keeping track of the child—and does the child pay attention? Look for signs of friendship and tenderness between parent and child, and see if you can spot any unique interchanges. A moderate zoom lens will help you make pictures of these things unobserved.

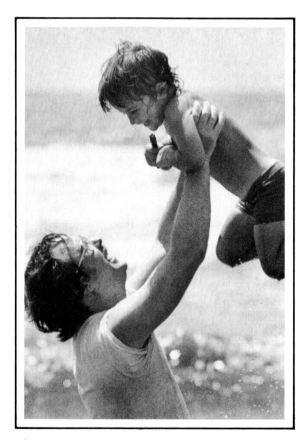

Tender moments are easily, even if unintentionally, intruded upon with a camera. To avoid disturbing your subjects and still have them fill the frame, use a long focal length lens. Photo: J. Peppler.

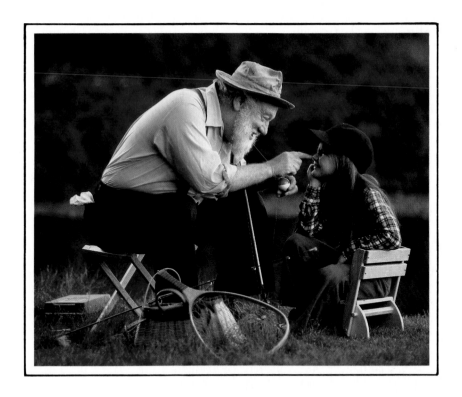

In many families, a special relationship exists between grandparent and grandchild. The mutual respect and friendship of the two often becomes most obvious as they share a hobby or pastime. If you work quietly and keep at a discreet distance, you will find it easier to capture moments such as the one shown here. Photo: W. Hodges/West Stock, Inc.

If the family you have chosen looks friendly and you are sufficiently intrigued, go over and introduce yourself. Make mention of the fact that you are taken with the way they interact, and ask them if they would be interested in your making a group portrait of them at their convenience; or, failing that, ask if they would be interested in pictures of their child or children. The worst that can happen is that they will decline your offer. In any event, you will have gotten some photographs of them.

Children will often imitate adults they like, sometimes unconsciously. The next time you are in a playground or park and there are adults there with their children or grandchildren, watch for this. Hand gestures, tilts of the body, facial expressions—all of these make good photographs when the parent and child do them simultaneously.

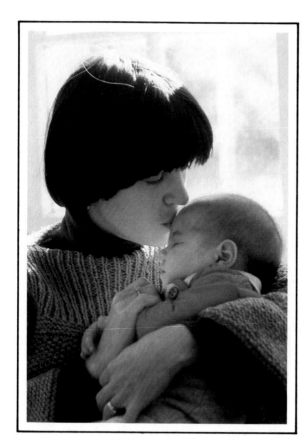

When photographing by existing light with your subjects' against a window, the outdoor light level is frequently much higher than indoors. One possibility is to make your exposure for the indoor level and allow the outdoors to appear too bright, but consider the approach on the opposite page.

One Parent/One Child. Making portraits of parent and child can be easier and at the same time more difficult than making individual portraits. For one thing, unless the child is being held in the mother's or father's arms, all of the normal lighting problems you have will be twice as difficult to solve. For another, placement of two people of such different heights could be problematic. You can solve this by asking the parent to sit while the child stands nearby or sits on the parent's knee.

Keeping the young child's attention, on the other hand, will usually be taken care of by the parent. The child will feel safe and relaxed since mom or dad is there. Normally, the parent will be engrossed in the child and will therefore not be too self-conscious in front of your camera, either. In addition, interaction between parent and child will enable both subjects to be themselves.

Family Groups. The most difficult kind of family portrait to make is one that includes both parents and more than two children. The kids are likely to have different personalities, and controlling all of them,

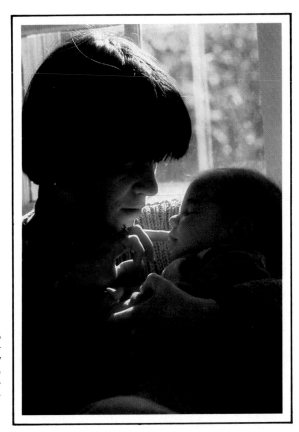

The alternative is to expose for the outdoor level and let your subjects' faces be darker than normal. There is no right and wrong in this situation; the choice is yours. Photos: T. McGuire.

even with the parents shouldering most of the burden, can be tricky. Getting everyone ready for the exposure at once without making them look stiff is not easy, either. Wait for a moment of laughter or a lull in the conversation, then make your exposure. You will probably be better off if you don't expect them all to look towards the camera. The photograph will look less ritualized if it shows them conversing rather than staring straight ahead as if they all happened to gather in front of your camera by accident.

The easiest place to make group portraits is in the family's home. The surroundings will be familiar, and they will feel far more comfortable there than they would in your studio or some other alien locale. You can further enhance your chances of producing a good picture by leaving the room intact, adding no light stands or reflectors to change the mood of the home. Use available light if you can; if not, use bounce flash, aiming it off a light-colored ceiling or wall and making sure that you set the lens opening based on the distance the flash light travels, not on the camera-to-subject distance.

Family Gatherings

Whether it is a wedding, a family reunion, a graduation, or something less ritualized, family gatherings are great times to photograph kids. Children respond well to the sense of celebration, and look forward to seeing cousins and young in-laws. As the adults go about their festivities, youngsters make up their own games, make friends, and generally rush about, presenting numerous opportunities for picturemaking.

If you are invited to a family gathering and are not a member of the family, get the host to introduce you to the rest of the clan, including the children. Once you have been announced, most people will go back to their celebrating, leaving you free to make your pictures of the kids.

Making Candid Photographs. Candid, unplanned pictures usually work best. If the event is outdoors, bring a wide-angle lens, your standard lens, and a telephoto; or bring only a zoom lens that will perform all three tasks. Carry as little equipment as possible; you will be more mobile, and you will not run the risk of being dubbed the official photographer for the event. If you do get drafted into service as the photographer at a large reunion, you will be spending all of your time photographing various family members alone and in groups, instead of being left alone to follow the kids around.

In a circumstance like this it's next to impossible to know in advance the best lens choice. If you don't have a zoom lens, the best choice is a normal focal length—it will be right for the largest number of picture opportunities.

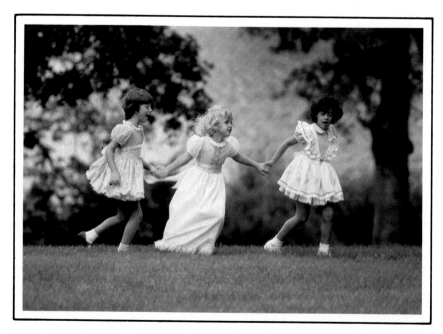

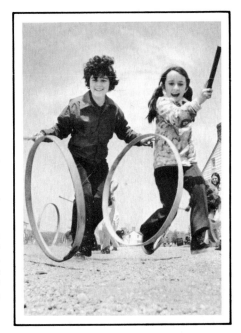

A low camera angle and thoughtful preparation combine to give a feeling of excitement. There really isn't time to move along with action like this; to capture it, you have to be waiting. Take a few minutes before photographing to see where the children will likely be when you're ready to press the shutter. Photo: J. Peppler.

If the gathering is relatively small, you might offer to record the event for them; it will not take long, and the kids will get used to your moving around with your camera. After you have done your duty, you will be free to pursue your hobby anonymously. The novelty of being photographed will have worn off, and no one will pay attention as you raise the camera to your eye in search of your child photographs.

Sometimes children get so involved with one another at such gatherings that you can quite literally stand next to them and make pictures without their noticing. Use a slightly longer than normal focal-length lens to record their faces tightly, then move or zoom back to add some of the bustle of the surroundings. Photograph the expected—the child falling asleep in the middle of the commotion, for example—but watch for the not so expected as well, like the absentminded stroking of a child's hair by his or her father while he is involved in conversation with someone else.

Get the names and addresses of children you have photographed, and send their parents copies of pictures that you feel best show the children as they really are. There is a pragmatic as well as a polite reason for this: If the parents are pleased with your consideration, they will be more likely to sign a model release for the pictures should you wish to use them for publishing purposes.

Shoot more film than you think you need to, and bring twice as much as you think you will use. Film is still one of the least expensive components of the photographic process, even in this inflated age, and it weighs little.

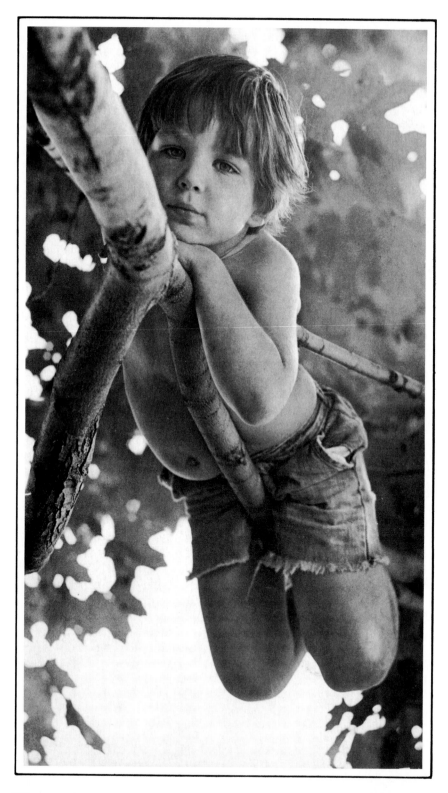

A Day in the Life of Your Child

Earlier in this volume we gave a few suggestions on how to record the growth of your children, i.e., by making photographs at important moments in their lives; by photographing them periodically, to get a visual record of the passage of their time, and so on. Here is another idea: try recording a full day in your child(ren)'s life.

Few people will have the time or the energy to actually take an entire day and devote it to making photographs of their children; but if you make photographs of different parts of average days, you will end up with a telling series of photographs that might give you new insight on how your child in particular and most children in general live their young lives.

Most of us remember what it was like to be young. At least, we think we do. Our memories of the small frustrations and disappointments have receded, while those of the pleasant moments of our youth have probably loomed larger. By documenting our children, we may come closer to the realities of childhood.

The first hurdle to overcome is your subjectivity. It is important to be objective when documenting your child or your record will reflect your perceptions about childhood. Of course, being objective about your own child is next to impossible and trying to cast aside years'-old ideas about childhood is doubly difficult. The best way to approach this project is to act the observer for a few days. Repress your parental urge to scold or order about—merely observe. Soon you will have an entirely new impression of your offspring. Then you can pick up your camera.

Equipment. Try the project with black-and-white film, available light whenever possible, and a standard lens. You might need a moderate wide-angle lens for some situations, and a slightly long one for others, but by and large, the standard focal-length lens will suffice for most of the pictures. We suggest black-and-white film for two reasons. First, it is less troublesome to use, since you need not be concerned with color balance or anything else that might take you away from concentrating on the subject. Second, if your photographs are successful, the graphic quality of black-and-white will be complementary, while color in the images might dilute what picture editors used to call their "impact."

A child's world extends into areas beyond the imagination of most adults. You may get your best picture ideas by following your young subject rather than by directing him.

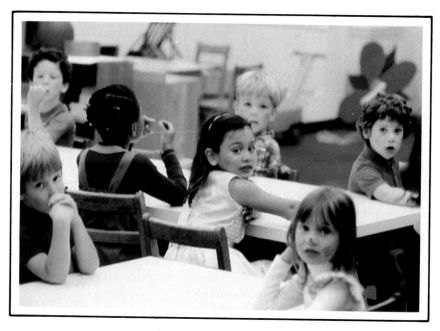

One point for photographing a day in the life of a child is to discover what goes on without your presence; try to resist the urge to rearrange a scene in the quest for pictorial order.

Following your child around with a camera for an entire day might be annoying. For this reason, documenting your child's life over a series of days is a better idea. If you take the project a step at a time, rather than trying to do it all at once, it will be easier to complete.

Morning Routine. Begin with your child's morning routine. Notice how he or she reacts to getting out of bed. Does he or she hop out quickly, as if looking forward to the day, or does he or she resent being made to get up? Record whichever attitude is more usual. If there are siblings, do they fight among themselves for the bathroom, or is there an established pattern? Do they play with one another? How and what do they eat for breakfast? Which one is most eager to go to school? Are they driven, do they walk, or are they bused? If they walk, what do they stop to look at along the way?

At School. Next, photograph your child at school. Getting permission to photograph in the classroom might be tough, unless you live in a small town and people know about your photographic interest. However, once you do get permission, you will need to make only one or two representative photographs. Since this project is as much an anthropological one as it is photographic, you might delegate the classroom

pictures to someone whose photographic ability you respect, but who will not embarrass your child the way you might by being in class with him or her.

After School. After school, when your child is at home, make pictures whenever you can—at meals, while he or she watches TV or does homework, while he or she plays with friends and (from a discreet distance) bickers with temporary enemies. Record moments of boredom, laziness, and frustration, as well as those of enthusiasm, industry, and success. Use a quiet camera and a gentle step, photographing unobserved without becoming furtive.

Learning About Your Child. In a few weeks at the longest, you will have made a pretty comprehensive study of the day-to-day existence of your child. You may discover from the photographs that your son or daughter is happier or more depressed than you thought; that he or she is more changeable or more predictable than you had imagined; or that you have photographed the child you already know better than you do any other.

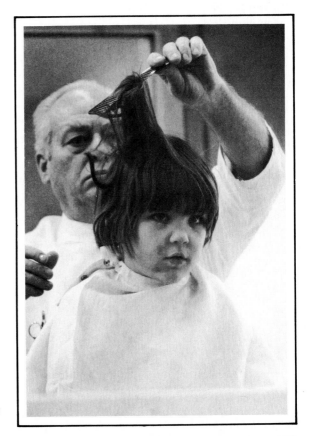

A mirror is a handy device for picturing a subject frontally, yet unobtrusively. Remember to photograph the reflecting surface at an angle unless you want your own reflection to be in the frame.

6

Let the Kids Do It

Not only are children fascinating as photographic subjects; they are also often good sources for picture ideas. More than one well-known photographic artist has built his reputation on pictures made from ideas supplied by the children in photographs.

Children's eyes are not so lazy nor so jaded as ours are; nor have their imaginations become numbed by the idea that certain things are impossible. If you let your subjects dictate the content of the photograph, you might be pleasantly surprised at their originality. Do this a few times with one child, and you will have a clearer understanding of how he or she sees the world. That kind of knowledge will enable you to create better pictures of childhood almost immediately.

If you have interested children of your own, or are friendly with someone small who is interested in photography, you might encourage that interest by explaining photographic concepts, and by letting the child participate in the process. Show interested children how photography can help them further their interest in nature, the arts, and architecture. If you have the time and inclination, you might volunteer your services as a photography instructor at a local YMCA or scout troop.

Help kids further their photographic interests by devising photographic projects for them to work on. If any children are interested in printing, show him or her how to set up a darkroom, make contact prints, develop film, and so on. If you have never done this before, you will be surprised at the speed with which certain children grasp the fundamentals of camera manipulation, exposure, and picturemaking in general.

One excellent way of increasing your own understanding and appreciation of children is to let them show you how they see the world. Give an interested, curious child an easy to use camera; you might be surprised and delighted at the pictures he or she will come up with. Photo: S. Vespucci

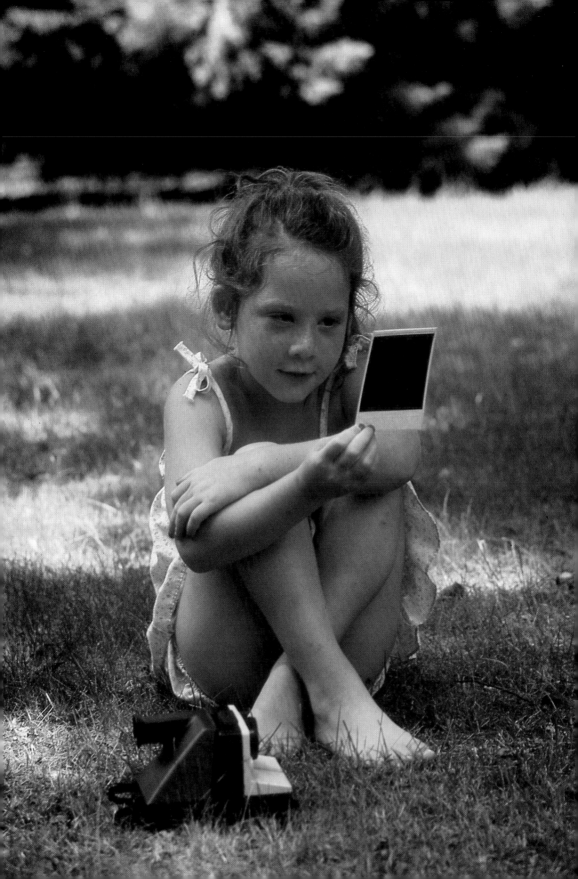

Your Child as Art Director

If you are ever stuck for a photographic idea, listen to your children as they think out loud. Questions like, "Mommy, can the bird see the whole park from the tree?" demand an answer; and what better way to provide one than to get up in the tree with your camera and bring your child visible proof of just how much the bird can see? You would never have climbed the tree for a bird's-eye view unless your child had suggested it; and after you've climbed it, your child's renewed appreciation of your athletic ability (we hope it was a small tree) will have been worth the effort. In addition, you will have shown your child something of the power of photography—not so much the ability to see what a bird sees but the potential to realize in tangible form the things that otherwise might have to remain locked in the imagination.

Children are full of unexpected perceptions, seemingly unanswerable questions, and some truly wonderful ideas, a lot of which can be translated into photographs. When you are making pictures of your kids, or anyone else's for that matter, ask them how they would like to be photographed. Let them act out their fantasies for you. Supply props and costumes, if necessary; and get them to be even more outgoing by making a few exposures with an instant camera, so that they can see immediate results. Instant print cameras are at least as good at breaking the ice with youngsters as the advertisements suggest, and no child photographer ought to be without one.

Interview your kids about how they see themselves; let them decide where the next photographs of them should take place, and under what conditions. If it is the middle of August and your daughter wants to be photographed in her snowsuit, photograph her in the snowsuit. What at first might seem like willfulness or a test of your patience might turn out to be the budding of a surrealist imagination.

Acting Out Fantasies. We have said a few times that photographs of children are far more likely to be successful if you have the children think of the session as a game; this time, allow them to determine the rules of the game. The kids might be a bit frivolous at first, hamming it up for the camera; but in a while, if you express a genuine interest in the way their minds work, you will find them more willing to participate in your ideas and ready to share their serious ones with you.

If the hypothetical daughter mentioned above sees that you really found her summer snowsuit idea interesting, she might begin to act out

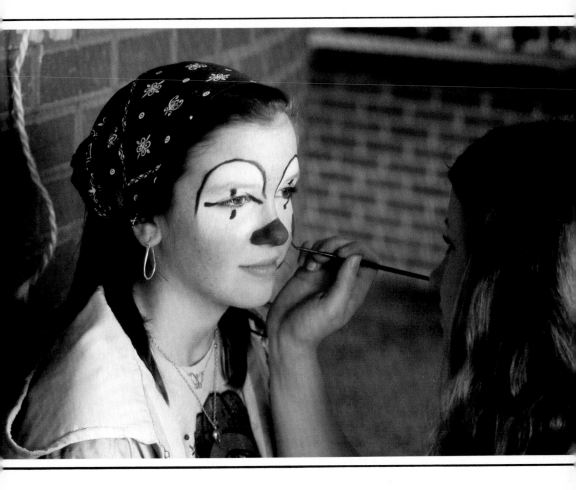

When a delicate and demanding action is taking place, it's courteous not to use a potentially disturbing artificial light source. Instead, load your camera with a fast film (ISO/ASA 200 or higher) and be prepared to improvise a camera support should a slow shutter speed require it. Photo: M. Fairchild.

all kinds of roles in various costumes. Think how much better a series of well done fantasy "dress up" pictures of your daughter would be than the standard, run of the mill poses in the backyard at barbecue time.

If you have more than one child, get them all to come up with picture ideas. Let them assign you a role as well, getting you into the scene. Your self-timer can trip the shutter.

In years to come these may become some of the most valuable pictures you have of your family; they will not only show how your children looked, but how they imagined as well.

Helping Children Develop Their Interest in Photography

At any age up to the teenage years, most children who express an interest in photography are more concerned with the product than they are with the process. They are curious and sometimes a little awed by the box that makes pictures happen, but the pictures themselves are where the heart of their interest lies. Still, curious children will ask, "What makes the picture happen?" You will have to come up with a simple explanation, avoiding such words as "latent image" and "aperture." They can see and touch things like the "shutter button." When they depress it, they can hear the shutter, which is just as good as seeing it.

Encouraging Interest. Encourage their interest by explaining what happens in terms of things they can experience first hand. Show them how the lens opening gets larger or smaller depending on which way you turn the ring; let them hear the different sounds the shutter makes at various speeds, and explain the concept of exposure. Tell them that if less light gets into the camera, the picture will be darker; and that if more light is allowed in, the picture will be lighter. This kind of information will satisfy most kids under ten years of age, and will be all they need to know about the fundamentals of exposure at that age. If they see you putting a yellow filter on the lens, tell them it makes the clouds stand out, then later show them comparison pictures of the scene made with and without the filter. Let them come to you

Children should be encouraged to take cameras along on everyday excursions, such as to the park or playground. They should photograph whatever strikes their fancy. Cameras and film should not be saved just for special occasions.

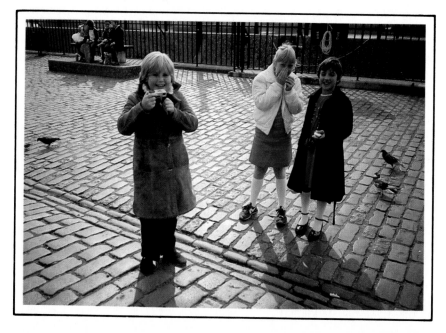

with questions. Answer them patiently and with as little theoretical explanation as possible. If you do not force photography on your children, you will stand a better chance of nurturing their interest.

Teaching Criticism. Look at photographs with your kids. Ask them to bring you their favorites from magazines and newspapers, and discuss their reasons for picking the ones they did. If you think they are old enough, show them your photographs and ask them which they like best and why. Show them the work of well-known photographers/ artists, so that they can see that photography can be used for purposes besides news and advertising.

Let them make an exposure or two with your camera every now and then; make prints of their efforts, and praise them for their successes. Let them keep the prints and hang them in their rooms if they want them there. If you have a space reserved in the house for your kids' artwork (the refrigerator door seems to be a favorite spot) exhibit their photographs there. Be as supportive as you would of their schoolwork, musical ability, or athletics, without getting pushy.

As they approach their teen years and are not likely to be a nuisance or a hazard in the darkroom, bring them inside and show them how a print is made. Seeing an image come onto paper is a piece of "magic" no photographer has ever forgotten.

A long focal length lens makes the background appear closer than it does to the eye. Use one to emphasize the confusion and crowded feeling in a scene such as bumper cars at an amusement park. Photo: E. Stecker.

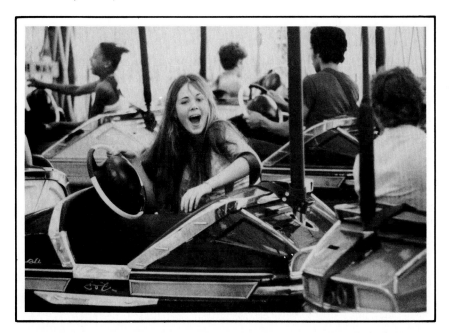

Camera Equipment for Kids

Most youngsters interested in photography will want to see what they have made as soon as possible. This makes the instant-print camera an ideal learning tool. The less expensive versions are made of sturdy plastic, have few controls to master, and spew forth the picture with a satisfying "whirr" that most children find irresistible. Seeing the colors come to life as the print develops before their eyes is something they are not likely to forget, either.

Instant Cameras. With an instant camera and a flashbar or two, your child can produce the same sharp, well-exposed images you can. One drawback of these cameras, however, is the high price of the film because the filmpack contains the battery that powers the camera and because the film is expensive to produce. But the high price can be an advantage in teaching your child the value of film and the virtue of careful framing. You may have to ration the film at first, until the novelty of the instant print wears off. At the same time, explain patiently that the instant camera is not a toy and that film is expensive.

110 Cameras. Less impatient and older kids will be better off with a 110-format camera. Most of these are easy to use, provide passably good results (as long as you do not enlarge the negatives too much), and the film's price will easily fit into the kids' budgets. Because of the simple viewfinders and controls of 110 cameras, your children will be able to concentrate on seeing photographically instead of fiddling with dials and paying attention to LEDs (light emitting diodes) flashing in the finder.

35mm Cameras. If your children of 12 or so display a genuine interest in photography, nurture it by giving them better equipment. A small automatic 35mm rangefinder with built-in flash and a good lens would be ideal. At this age, most kids are ready to learn how to process their own film, make contact prints and simple enlargements, and so on. Various schools and organizations, such as the Boy Scouts, have full-scale photography programs for boys and girls entering their teens; if your child attends such a school or belongs to an organization with a photography program, he or she will be able to share the interest with contemporaries, picking up new information and insights as he or she does so.

If your 12-year-old expresses a desire for more sophisticated camera equipment, come to some sort of arrangement whereby he or she can earn it. Kids, just like adults, are more likely to take care of something they have had to work for than something they got for nothing. Try to instill in children the old but valid idea that the photographer makes the picture, not the camera, so they should have a specific, photographic need for each piece of hardware they want.

Children are more likely to take a camera along wherever they go if it is really their own, not on loan. Picture-taking will lead them to discover and learn new things, and it's fun to do. Photo: C. M. Fitch.

Photographic Projects for Kids

Before you decide on any project for your children, let them photograph for a month or two. Once they have gotten over their first romance with the camera, during which time they will point the lens at anything in sight, a pattern might begin to emerge. Does one of them appear to concentrate on people? If so, do the people have anything in common besides being within easy reach? Or is the camera rarely, if ever directed at other people? Does your son or daughter like to make pictures of wide open spaces, automobiles, or animals? If there appears to be a thread tying most of the pictures together, suggest a project based on the theme the child has already established. Suggest to the child who photographs pets that he or she pick one animal and photograph it in as many different ways as he or she can think of. If your child likes to make pictures of courtyards or buildings, suggest that he or she make pictures of the "best" and "worst" buildings or courtyards around, and so on.

Providing Structure. If there is no common thread, do not worry —even some art students have difficulty concentrating on one area until they have reached their third year of college, so your budding photojournalist has plenty of time to play around. You can help matters by providing structure. Have "shootouts" with your kids: Photograph them while they photograph you; take turns making portraits of

A good way to visually subdue an out-of-focus foreground is to burn it in with extra exposure during printing. The foreground will still be present, it just won't command the viewer's attention so much.

In the unlikely event that a young, beginning photographer finds him or herself at a loss for things to make pictures of, suggest that he or she incorporate photography into some already established hobby or area of interest. This photograph was made by a youngster who has always loved birds. His photographic efforts now give him a means to make lasting images of his favorite creatures.

each other; have your budding photographer make pictures of his or her siblings; of the family pets; of the refrigerator—of anything that comes to mind. Suggest that the child make a photo map of the path from his room to the kitchen, using an entire roll of film to make the exposures, then taping the prints together in the correct sequence to show the way. Have him or her document the gradual disappearance of fruit from the bowl on the dining room table, suggesting that if it is an especially slow day for fruit, the photographer might speed up the process a little.

Projects. For older kids, you might suggest the same kinds of projects you have undertaken yourself. Ask your child to keep a periodic visual record of his or her siblings; describe the concept of an environmental portrait and see what he or she can do with you as the subject. Suggest titles such as, "What is Wrong with This Town" or "Me Ten Years from Now," and see what happens.

Be supportive of your child's efforts, even if the results are far from perfect. Tactfully, point out obvious mistakes that can be easily corrected. In time, your offspring will get to know all of the techniques necessary to produce meaningful photographs. Until then, he or she will be gaining a better understanding of how to see through a camera than he or she would get from a subscription to a photo magazine.

Index